$$A = f(N \cdot C)$$

$$A = \int (R \cdot N \cdot C)$$

Figure, Form, Formula

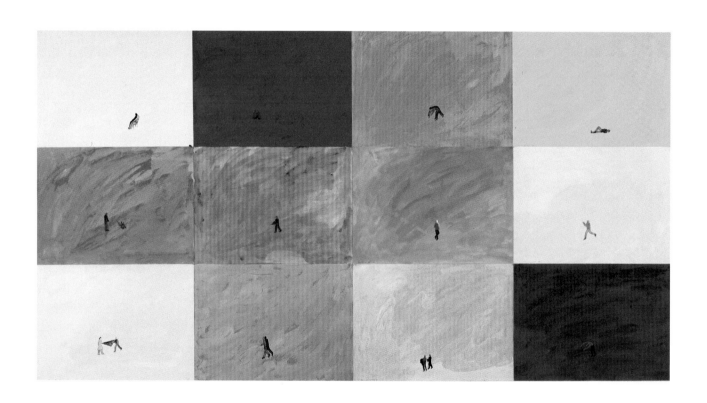

Figure, Form, Formula
The Art of Pinchas Cohen Gan

Exhibition curators

Ruth K. Beesch and Kristine Stiles

Weatherspoon Art Gallery

The University of North Carolina

at Greensboro

Major funding for the Israel/North Carolina Cultural Exchange has been provided by the North Carolina Department of Cultural Resources and the State of Israel.

©Weatherspoon Art Gallery, The University of North Carolina at Greensboro, 1996
Library of Congress Catalog Card Number 96-061013
ISBN 0-9627541-7-X

Figure, Form, Formula: The Art of Pinchas Cohen Gan
was organized by the Weatherspoon Art Gallery

 Editor: Nancy H. Margolis

 Designer: Jennie Malcolm

 Printer: Harperprints

 Photography:

 Dan Smith, Learning Resource Center, The University of North Carolina at Greensboro

 Meidad Suchowolski, Tel Aviv pp. 9, 21, 31, 56–67, 70, 72–73, 82

 Kristine Stiles p.116

 David Harris, The Israel Museum pp. viii, 76

 Avraham Hay, Tel Aviv Museum of Art: Cover

An edited version of *Pinchas Cohen Gan, Activities* (1974) is reprinted with permission from The Israel Museum, Jerusalem.

Cover:
Composition
(Coefficients of Painting, Sculpture, Drawing, and Architecture)
1978
Pencil, oil, acrylic, and wood
Tel Aviv Museum of Art

Frontispiece:
Figures 1–59
1977
Oil wash and cutouts
Collection of the artist

Lenders to the Exhibition

Pinchas Cohen Gan

The Israel Museum, Jerusalem

The Museum of Israeli Art, Ramat Gan

Tel Aviv Museum of Art

Donors

State of North Carolina,
Department of Cultural Resources
State of Israel, Ministry of Foreign Affairs

The Mary Duke Biddle Foundation
The Blumenthal Foundation
Carolina Power & Light Company
EL AL
Glaxco Wellcome
The Kaplan Family Foundation
NationsBank
The Wachovia Foundation, Inc.

Mr. and Mrs. Arthur Bluethenthal
Anna Lou Cassell
Mr. and Mrs. Benjamin Cone, Jr.
Mr. Bernard Gutterman
Mr. and Mrs. Sidney H. Siegel

The Adelman Family Fund
Richard D. Adelman
Herbert and Ann Brenner Fund
Barbara and Harvey Colchamiro
Mr. and Mrs. Robert C. Cone
Jean B. Falk
Sara Frooman
Ronald and Susan Green
Greensboro Jewish Federation
Mary Gut
Mr. and Mrs. R. Philip Hanes, Jr.
Robert S. Kadis
Mr. and Mrs. Arthur H. Kurtz
Mr. and Mrs. Robert J. Lee
Henry Samuel Levinson
Dr. and Mrs. Myron B. Liptzin

Mazel Tov Gifts
Mr. and Mrs. Paul J. Michaels
Kay and Dave Phillips Foundation
Mr. and Mrs. Marshall Rauch
Stanley Robboy
Susan Rosenthal
Mr. and Mrs. Norman G. Samet
Dr. and Mrs. Paul Sarazen
Daniel Satisky
Gordon Smith, III
Leah Louise B. Tannenbaum
Mr. and Mrs. Smedes York

Mr. and Mrs. Frank Brenner
William L. Cassell
Thomas L. Chatham
The Dover Foundation, Inc.
Lynn and Barry Eisenberg
Mr. and Mrs. Stanley H. Fox
Bluma K. Greenberg
Mr. and Mrs. Howard Guld
Dr. and Mrs. Soloman P. Hersh
Mr. and Mrs. Daniel Horvitz
Cary and Susie Kosten
Ruth Leder
Mr. and Mrs. Ross Levin
Stuart J. Levin
Ruth Mary Meyer
Mr. and Mrs. Arnold Shertz
Thomas R. and Linda E. Sloan Fund
Robert Sosnik
Tex Williams
Mr. and Mrs. E. L. Woolner

Contents

First Aid Kit of Primary Colors
 1974
 Bag made of sewed cloth, oil, and stamps on paper
 The Israel Museum Collection, Jerusalem
 Gift of Arturo Schwarz

Preface and Acknowledgments

The exhibition "Figure, Form, Formula: The Art of Pinchas Cohen Gan"
is not the first showing of Cohen Gan's work at the Weatherspoon Art
Gallery. In 1977 and 1979, the Gallery included Cohen Gan in its annual
"Art on Paper" exhibition. It is appropriate that "Figure, Form, Formula,"
Cohen Gan's third showing in Greensboro, is a comprehensive survey of
his work to date, offering our audience the chance to see how his art and
his vision have matured.

This opportunity comes as a result of a series of fortunate events, foremost
among them the inspired vision of the Israel/North Carolina Cultural
Exchange. In 1994 Governor James B. Hunt initiated a bold and
progressive cooperation between the states of Israel and North Carolina.
Recognizing the importance of the arts, humanities, and education in
understanding our states' shared values, Betty Ray McCain, secretary
of the North Carolina Department of Cultural Resources, and Henry
Levinson, professor of religious studies at The University of North
Carolina at Greensboro, agreed to co-chair a task force to encourage
cultural and educational projects. With the guidance of Elizabeth F.
Buford, deputy secretary of the North Carolina Department of Cultural
Resources, and John W. Coffey, chair of the Curatorial Department at the
North Carolina Museum of Art, a Visual Arts Planning Committee was
formed, which quickly, and with great enthusiasm began to explore the
myriad facets of Israeli art.

Ruth K. Beesch

In connection with the Israel/North Carolina Cultural Exchange, co-curator Kristine Stiles and I took an illuminating visit to Israel in fall 1994. Knowing little about the work of Israeli artists, we were confronted with a complex and sophisticated art scene. Although I had at that time no knowledge of his connection with the Weatherspoon, one artist stayed in my mind—an artist whose work so impressed me that during our first visit to his studio I negotiated the purchase of several drawing's for the Weatherspoon's collection. Stiles and I agreed that an exhibition of the art of Pinchas Cohen Gan would be a stunning contribution to the Israel/North Carolina Cultural Exchange.

Two more trips to Israel ensued, the last with art historian Peter Selz. Each time we dug deeper into Cohen Gan's studio and psyche, and eventually we established trust, respect, and friendship. Such a collaboration is invigorating and satisfying, particularly when the chemistry is such that the curators and artist can exchange ideas, listen, learn, agree and disagree—always coming full circle.

The response of our Israeli colleagues has been very rewarding. Uri Ba Ner, deputy director-general for cultural and scientific affairs, Ministry of Foreign Affairs; and Arye Mekel, consul-general of Israel for the southeastern United States, offered welcome support and advice. Our art colleagues in Israel provided unparalled guidance, cooperation and professional assistance. My thanks to Mordechai Omer, director, and Edna Moshenson, curator, and Emanuela Calo, assistant curator, of the Department of Drawings and Prints, Tel Aviv Museum of Art; Meira Perry-Lehmann, chief curator of art and Judith Spitzer, associate curator, David Orgler Department of Israeli Art, The Israel Museum, Jerusalem; Meir Ahronson, director, Museum of Israeli Art, Ramat Gan; and Noemi and Sam Givon of Givon Art Gallery in Tel Aviv. Sergio Edelsztein served both as our "hostess" and as a most intelligent and provocative companion. Marge Goldwater provided us with excellent references and readily shared her knowledge of contemporary Israeli art.

In the North Carolina community, many individuals were particularly helpful in assisting with the fund-raising for this project. I would like to thank Joanne Bluethenthal for her support and leadership and the many members of the fund-raising committee, who worked with great energy and enthusiasm to support the Israel/North Carolina Cultural Exchange. A special note of appreciation is due to Bill Cassell for his good advice and endless networking.

The hard work of many professionals associated with the Weatherspoon Art Gallery made this exhibition and publication possible. This publication would not have been realized without the talent and expertise of graphic designer Jennie Malcolm and editor Nancy Margolis. Ruth Cook, development coordinator; Anna Upchurch, public relations coordinator; and Paula Mehlhop, administrative assistant to the Curatorial Department at the North Carolina Museum of Art each contributed to the success of the Israel/North Carolina Cultural Exchange and this project in particular. Eti Welisch of Baumer and Model coordinated the complex task of packing and shipping art from Israel with extraordinary efficiency. Finally, as always, the entire staff of the Weatherspoon Art Gallery supported this project with pride, humor, and a standard of excellence that is in my opinion unmatched by that of any other team of professionals.

To my colleague Peter Selz, professor emeritus, University of California at Berkeley, I extend warm thanks for his insight, intelligent writing, and the benefit of his excellent eye. Throughout this project, my colleague and co-curator Kristine Stiles, associate professor of art, Duke University, was a constant inspiration, a challenging collaborator, and a lot of fun. I have not worked with anyone whose energy, brilliance, and commitment to excellence were greater.

Finally, it is impossible to adequately express my admiration and great respect for Pinchas Cohen Gan. From the first time that he invited us into his studio, through the process of selecting and organizing this exhibition, he invested tremendously of himself. So many hours of interviews, patiently going through works of art, so many questions, and lots of written correspondence. What is now so obvious is the extra-ordinary depth of his *oeuvre*, the passion and intellect he has brought to pursuing the making of his art, his dogged resilience, his wry humor, and the deeply held values that inform his creative explorations.

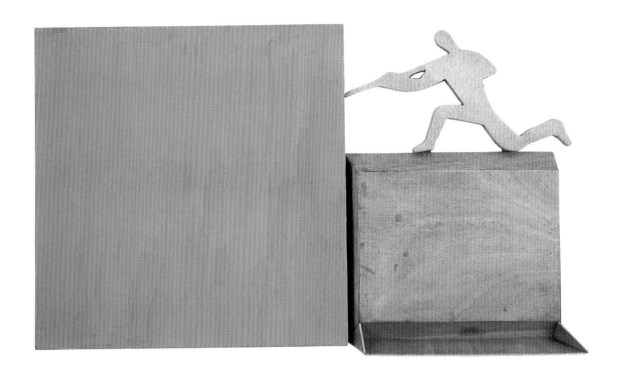

Propositional Painting
1980
Acrylic, canvas, and wood
Collection of the artist

Foreword

The complex art of Pinchas Cohen Gan translates his life experiences into an existential and aesthetic model: Figure/Form/Formula. He appears in his work both as an actual person and as a metaphorical figure that enters the field. But once in the field, he—like the viewer—becomes any figure, a form against the field. The figure is the form of an infinitely variable formula for the production of images, objects, and actions. Thus, the artist provides a variable picture-plane against which he and his viewers may substitute experience, perception, and conduct as figures active in a field. This enables Cohen Gan to approach his goal, his spiritual target: to engage art actively in the social and political environment of his immediate society as well as in international culture.

Form is always in the center of Cohen Gan's triangulated model. Form represents the work of art, the art that is the catalyst of Pinchas Cohen Gan's world, the bastion from which he launches his engagement with the world. This catalog weaves back and forth through Cohen Gan's activities, prints, paintings, and construction, diary entries, and theory on a complex path that leads to some of the meanings and intentions of his work. If the path is twisted, littered with roadblocks and detours, it is because the spiritual target is difficult to hit.

Kristine Stiles

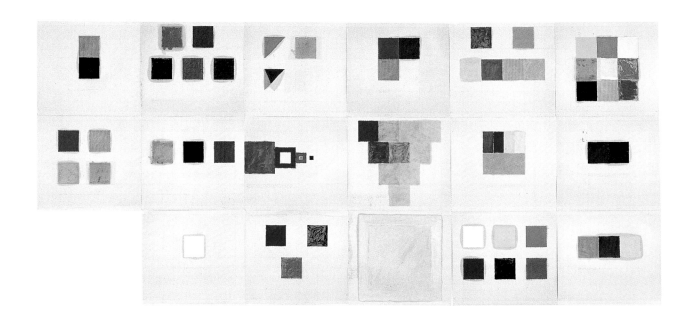

Definitions 1–17
 1975
 Oil on graph paper
 Collection of the artist

Biography, Nature, Mystery

Art and the making of art are, in the final analysis, a "black box," whose mysticism threatens the rational world. The world of prophecy and mystery mobilizes the world of cognition in order to save it from certain death.

Pinchas Cohen Gan

Who is Pinchas Cohen Gan? How can we reconcile the polarities of his expression? Both an intellectual and a humanistic thinker, Cohen Gan embraces metaphysics while investigating scientific systems. He walks a thin line between the rational ideal of Western logic and the mystery and intuition of Eastern thought. He writes emotive verse, but diagrams mathematical and linguistic schemes for attaining some action or object (usually the creation of art). Time and again his art and writings embrace, sometimes contradict, incorporate, and frequently critique principles and theories of philosophy and science.

Ruth K. Beesch

Through his art and writings Cohen Gan conducts his own subjective investigations into mathematics, linguistics, and cybernetics. Are these investigations, which are visually and intellectually intriguing, and often seemingly dense, an attempt to create a dialectic that validates the integration of art and science? Are they simply complex systems whose implications hover around his pictures like some special effect? Rather, these investigations are the artist's way of tempering his inherently metaphysical approach to making art with analytical methodology.

1

Art and Language

quotations provided by
Pinchas Cohen Gan

Art and Language

The laws of mathematics and logic are true simply by virtue of our conceptual scheme.

W. V. Quine

*Concepts without percepts are empty.
Percepts without concepts are blind.*

Immanuel Kant

At the basis of the whole modern view of the world lies the illusion that the so-called laws of nature are the explanations of natural phenomena.

Ludwig Wittgenstein

The development of Cohen Gan's art and writings is informed by an understanding of his biography. He was born in Meknes, Morocco, in 1942, during the Vichy occupation of that country. Early childhood displacement shaped his values. In 1948 his family left Morocco seeking refuge in Marseilles, France. A year later they emigrated to the newly declared state of Israel. His father bought property and built a home in the small town of Kiryat-Bialik near Haifa. It was in this village, founded by German Jews in 1933, that Cohen Gan first experienced racism. As Sephardic Jews and Moroccans, his parents and four brothers were considered "oriental" and inferior by many European Jews. However, his traditional Sephardi upbringing, with its spiritual and emotional interpretations of the Bible, profoundly shaped young Cohen Gan. The scornful slurs and alienation of his boyhood and the universal values of his religious training clearly informed his struggle to develop a humanistic perspective.

At the age of eighteen, Cohen Gan left Kiryat-Bialik to serve in the Israeli army. In 1966 he enrolled in the newly founded Art Department of the Bezalel Academy in Jerusalem. A traumatic event marks Cohen Gan's student years in Jerusalem. Late in 1968 he was severely injured when a car bomb exploded, killing eight people. His print *Bandaged Figure* (1968) embodies his sense of growing alienation and questioning of the meaning of human existence. It may also be viewed as Cohen Gan's attempt to deal rationally and directly with psychic shock.

Upon receiving his Bachelor of Fine Arts degree from the Bezalel Academy, Cohen Gan, like a number of young artists who were his contemporaries, spent a year in London, pursuing postgraduate studies at the Central School of the Arts. At Bezalel, Cohen Gan had learned experimental new printing techniques such as photoetching and silk-screening, printing on all sorts of materials. In London, he continued to work in this medium, while observing artists such as Francis Bacon, Joseph Beuys, and Yves Klein. Immersed in the Pop culture of late-sixties London, and experiencing the isolation of being alone in a large city, Cohen Gan created works such as *Family Portrait* (1970–71), appropriated from an image in the *Daily Mirror*, and *Figure and Order* (1971), which deliberately stripped all personal individuality from their subjects, thus commenting on the existential nature of life.

Upon returning to Israel, Cohen Gan became an instructor at the Bezalel Academy. (Bezalel promoted him to full professor in 1990. But in 1993

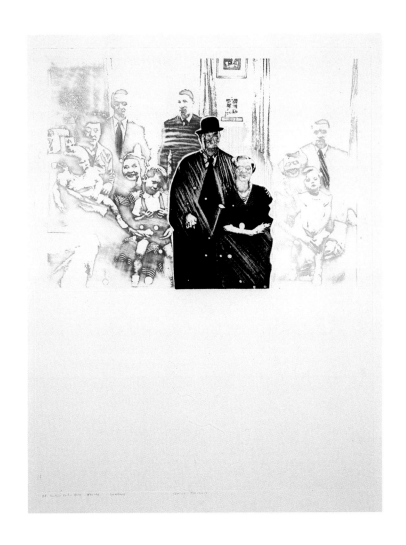

Family Portrait
1970–71
Photo-etching and embossment
Collection of the artist

he abruptly resigned because Sephardic Jews were not offered equal academic opportunities, and the arts were not held in the same esteem as the sciences.) In 1972 he was called into the army reserves where, as he describes in *Orphan's Kaddish,* he suffered a nervous breakdown.

What seems to have sustained Cohen Gan in the face of trauma, real and perceived, has been his ongoing quest to use theoretical fields of study such as philosophy, mathematics, and linguistics as an inspiration for his empirical and intuitive approach to making art. Historical figures such as Alberti and Leonardo da Vinci, who embraced scientific investigation, and Descartes and Spinoza, whose philosophies sought to clarify phenomena through mathematics, became models whose rational approach balanced Cohen Gan's emotive and expressive inclinations. The writings of the British mathematician Bertrand Russell, whose application of the concepts of logic provided a scientific structure for the study of mathematics (and whose social consciousness is reminiscent of Cohen Gan's), and the theories of Ludwig Wittgenstein, whose linguistic analysis maintains that "philosophy may in no way interfere with the actual use of language; it can in the end only describe it," also informed Cohen Gan's investigations.[1]

At the same time, however, Cohen Gan has always been instinctively and inherently drawn to the mystery of the human spirit's power to shape reality. Whether Cohen Gan was capable of achieving a pictorial synthesis balanced by these divergent principles is not the point. "Saving" his art from his own empirical tendencies and presenting it in rational and humanistic terms was his immediate goal.

Cohen Gan's first solo exhibition was held in 1972 at his own initiative in a cowshed at the Kibbutz Nirim. Organized as an Activity of protest against the establishment, it marked the beginning of a series of *Activities* that took place between 1972 and 1976. Many of these *Activities* offered Cohen Gan opportunities to explore and document conceptual ideas about man and nature, race and culture, nationality and territories, physical places and social places.

In particular, his Activity *Touching the Border* sought to promote a humanistic exchange following the Yom Kippur War of 1973. Cohen

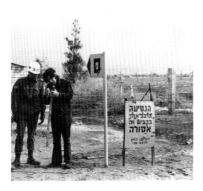

Gan and three artist-friends (described in the Activity as Israeli citizens) each traveled to one of Israel's four borders, with Lebanon, Egypt, Jordan, and Syria. At each border, after "the citizen" was stopped by the Israeli army, he proceeded to bury a 39-inch lead bar across the actual line of the border. The bars were stamped with demographic information on the number of soldiers enlisted in the armies of Israel and her border neighbor, and the number of soldiers from each country killed during the Yom Kippur War. Cohen Gan also sent a letter to the artists' association in each country requesting them to carry out a similar Activity on the border. The logistics of organizing and documenting this Activity may be interpreted as an attempt by Cohen Gan to distance himself emotionally from the devastation of war. If so, he was not entirely successful as his print *I'm Too Upset For Art* (1974) vividly illustrates.

Concurrent with his *Activities*, Cohen Gan participated in a group called Art & Science at the Bezalel Academy. This group sought to use the computer in the service of art, particularly to analyze and organize data that would be used by artists to offer creative alternatives to uninspired solutions for various civic projects. One such Art & Science project was Cohen Gan's proposal to use the computer to create a visual identity for a utopian and nonhierarchical transportation system in Jerusalem.

Although Cohen Gan was eventually disappointed by his efforts to realize this symbiotic integration of art and science, he did not abandon his investigations. Cohen Gan's three papers, "On Drawing" (1973); "Art &

Clockwise from top:
I'm Too Upset for Art, detail
 1974
 Photoetching and aquatint
 Museum of Israeli Art, Ramat Gan

Border Contact
 1974
 Photoetching
 Museum of Israeli Art, Ramat Gan

Cohen Gan and Israeli border patrol, *Touching the Border,*
7 January 1994

Art and Trauma

Thou shalt not kill.

Exodus 20:13

We say today in a loud and clear voice, enough of blood and tears, enough.

Yitzhak Rabin
1922–1995

There are more things in heaven and earth, Horatio, than are dreamt of in your philosophy.

Shakespeare
Hamlet

Science Project" (1973); and "A State of Mind, Manifest-On Art" (1974), are attempts to rationalize their subjects (i.e. drawing; public transportation in Jerusalem; and the nature of art itself) with analytical schemes and philosophical statements. His later papers cover much of the same terrain. Although these writings do not explain the essential nature of Cohen Gan's art, they do provide insight into the concrete elements that periodically temper his intuitive impulses.

In 1975, seeking an opportunity to participate in the international art world, Cohen Gan enrolled in the Master of Fine Arts program at Columbia University in New York City. There, his interest in philosophy, criticism, and art history led him to study with Meyer Schapiro, Arthur Danto, Lawrence Alloway, and Robert Pincus-Witten. Cohen Gan's time in New York was both fruitful and emotionally trying. While concentrating his studies on theory and remaining engaged in the conceptual ideas of his *Activities*, he began to make works of art in series, such as *Visual Mathematics* and *Language Trees*.

Cohen Gan's works from this period appear to be increasingly concrete in their formalism, incorporating both nonobjective and figurative painting and collage with statements that relate to mathematical and linguistic principles. These statements, however, should not be interpreted as definitions for, or explanations of, content. At this time, minimalism was reducing pictorial elements of art to their most essential components, and conceptual art was seeking to elevate the idea over the object. In some ways, Cohen Gan's work from this period seems a continuation of these ideas. In fact, however, his art was attempting to question, albeit in a relatively nonconfrontational manner, the very tenets of formalism that gave rise to minimalism and conceptual art in the first place: "I arrived in New York in 1975. The main problem in art that faced me then was the confrontation between the two poles: formalism and a-formalism. The formalist artists were proud of their ability to analyze reality with rational tools and to give them an experiential plastic translation. In contrast, the non-formal artists were scornfully dismissed since their connotation was the negation of reality or a refusal to accept reality as it was. This problem troubled me from a rational point of view."[2]

Soon Cohen Gan found himself confronting current artistic theory, realizing that rational and analytical methodology was of the order, and questioning its authority. It was his contention that strict methodology

thwarted creativity and limited discovery and innovation, which in turn reinforced the status quo and ultimately led to stagnation and resignation.[3]

Although seemingly formalist, a work like *Visual Mathematics,* which uses geometric shapes such as squares, deliberately avoids a repetitious, sequential, or systematic approach to organizing them. Late in 1975 Cohen Gan elaborated on this idea by conceiving his own empirical formula, $A_1 = f(\text{N·C})$, which means that art is a function of nature multiplied by culture. This formula was Cohen Gan's way of creating meaning in his work by acknowledging the impact of nature and culture. At the same time it allowed him to impose a logical system upon his art.

Although Cohen Gan's work was shown in numerous solo exhibitions at Rina Gallery in New York City and Max Protetch Gallery in New York and Washington, D.C., as well as in Jerusalem and Tel Aviv, and was reviewed by Robert Pincus-Witten, John Russell, and others, the artist was struggling financially, often painting on tablecloths and napkins, castoffs from the demolished Raleigh Hotel in Soho. In 1977, after he received his degree from Columbia, his status as a refugee (again) and sense of alienation contributed to his decision to return to Israel.

In 1976, one year before he returned to Israel, Cohen Gan conceived of a strategy to further his investigations of art and science by introducing a third element, the human figure. Calling this strategy Figure/Form/ Formula, he embarked on a series of works in which he attempted to fuse life (figure), art (form), and science (formula) into a triumvirate of corporeal, spiritual, and rational synthesis.

Works from his *Figure, Form, Formula* series give the impression that Cohen Gan believes that art and science are analogous. His human figure, androgynous and amorphous, may be interpreted as part of a "stick-figure scheme," a figure who is cloned, represents universal values, and fits neatly into a status quo social system. On the other hand, while appearing anonymous, Cohen Gan's figure seems imbued with psycho-logical tension, isolation, and the chaos of reality. In 1983 Mordechai Omer observed that in Cohen Gan's work, "the isolated personality lives in seclusion inside the fortress of itself, surrounded by formulae and systems which swing it about without it being able to connect itself to them."[4]

Cohen Gan also made use of figures and forms to explore definitions of space and visual perception, making works of art that attempted to use principles of non-Euclidean geometry. As Rudolf Arnheim explains, "We are accustomed to thinking of the world as an infinitely large cube whose space is homogeneous, in the sense that things and the relationships between them do not change when their location changes. But now imagine one side of the cube shrinking to the size of a point. The result will be an infinitely large pyramid. Such a world would be non-Euclidean."[5] Because non-Euclidean geometry is inherently anomalous, it is not surprising that Cohen Gan would gravitate to this unconventional and mutant stepchild of mathematics.

In non-Euclidean space, the perception of scale, not size, remains constant, and the nature of the scale is determined by the spatial framework. Objects or forms of very different sizes may be perceived as the same size, or equal to one another, while objects of similar sizes may appear not to be related at all. In *Blue State* (1982), Cohen Gan inserts geometrical forms into a picture plane devoid of structural space. The forms define the space and serve as the system that keeps his abstracted painted surface from disintegrating into an emotive and highly expressionist work of art.

Into the 1980s, Cohen Gan, now living and working in Tel Aviv, continued to make art related to *Figure, Form, Formula* and his other earlier series. Well aware of postmodern theory, he explored themes such as the remaking of history (his own history deconstructed in his "Biography of Creation") and wrote several papers, including "Critical Art, Hermeneutic Model" (1988), and "Biblia Principia Descriptiva" (1989), which outlined positions for linguistic interpretation, deconstructionist theory, and the ethical and logical translation of the Bible to art. Eventually, completely dissatisfied with his attempts to integrate metaphysical and analytical reasoning in his art and writings, Cohen Gan began work on a model for a meta-language, a language that would describe his ideas and theories of art.

A manifestation of Cohen Gan's meta-language was *Atomic Art*, published by the Bezalel Academy in 1982. Through *Atomic Art* Cohen Gan hoped to relate the visible world (nature) and the world of creation (art).[6] Concurrently, Cohen Gan found in cybernetics one more scientific system on which to build yet another analogy, in this case between the functions of the human nervous system and complex electronics. In 1983 he wrote,

Blue State
1980
Charcoal, brush, and ink
Tel Aviv Museum of Art
Gift of the artist

"Thus, when we talk about atomic art we talk about the relationship between the concrete substance of matter and its structure. Its visual appearance is judged by subjective and mental attitudes."[7]

In the last six years Cohen Gan has continued to use his art to investigate and critique the application of semantics, simulacrum, and from a particularly humanist position, semiotics. Several of his series deal with titillating commercial images of women, and others appropriate the work of his students, commissioned to make paintings based on exact representations from photographs. (Neither series is included in the Weatherspoon's exhibition.)

Two bodies of work from the 1990s rely on the power of symbols, both literally and metaphorically. In a group of works dating from 1991, Cohen Gan takes as his subject the scud missiles of the Gulf War. These works intersperse brilliant disks of color with Cohen Gan's human figure, the Star of David, and epithets related to the Holocaust. *The Foundation of the State of Israel from the Viewpoint of the Children* interweaves archival photographs portraying anonymous moments of abuse during the Holocaust with symbolic figures such as Theodor Herzl and Ben-Gurion to form a tribute that is both full of promise and laced with ironic expectations.

Ultimately, Cohen Gan has grown disillusioned, not with art or science, but with his attempts to establish a universal meta-language of art, and with the response of his audience. His disillusionment is clear in the third of his *Confessions* (1994; published in this catalog): "The third mistake of my life is my belief that art and science are universal in their essence and that a structural connection exists between them. To date, I have written six theoretical books on the science of art. My intention in writing these books was to preserve my sanity, on the one hand, and to conduct a dialogue with the centers of high art in Europe and America, on the other. Some ten years passed before I became aware of the fact that the group of believers in high art is dead."

That Cohen Gan distinguishes his art as "high art" is a testimony to the rigorous intellectual standards he has held for nearly thirty years. Never content to succumb to an inherently intuitive and metaphysical

orientation, Cohen Gan has actively pursued a synthesis of art and science, rejected its possibility, pursued an art informed by science and philosophy, and ultimately used scientific systems to create art whose humanistic perspective asserts his status as a human being. As Cohen Gan writes in his 1992 *Orphan's Kaddish*: "Everything vanishes. But art is always waiting, quietly, indifferently, but confidently."

Notes

1. Ludwig Wittgenstein, *Philosophical Investigation* (Oxford: Basil Blackwell, 1953), p.49.

2. Pinchas Cohen Gan, "Introduction to Art Now," *The Rational Factor in Works by Israeli Artists,* exhibition catalog (Haifa Museum of Modern Art, 1984), n.p.

3. Ibid, n.p.

4. Mordechai Omer, "Expression and Content in the Metalanguage of Pinchas Cohen Gan," *Pinchas Cohen Gan*, exhibition catalog (Haifa Museum of Modern Art, 1983), p. 87

5. Rudolf Arnheim, *Art and Visual Perception* (Berkeley: University of California Press, 1954), p. 289.

6. Cohen Gan, "Introduction to Art Now," n. p.

7. Cohen Gan, "Atomic Art, Meta-language in Art" (Unpublished paper, 1982–1983), n.p.

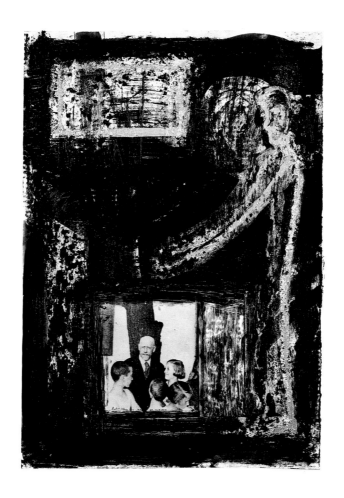

**The Foundation of the State of Israel from the
Viewpoint of the Children**
Dr. Korczak
 1996
 Oil, crayon, acrylic and photographs
 Collection of the artist

Orphan's Kaddish

Pinchas Cohen Gan

1 true, there's no point in feeding yourself with despair again:
that record is long out of date.
mytrip to paris didnt heal me,
but it gaveme the chance to know iwas born.

2 iwasborn in africa, iwasborn in morocco, iwasborn in meknes,
iwasborn into french culture.
iwasborn in the third world, iwasborn a jew — possessing
french culture, iwasborn a humanbeing.

3 at age five, imigrated for the first time.
at age six, imigrated for the second time.
at age five istopped being an ordinary person and became
a professional migrant.

4 ididnt know, then, that iwas an artist.
iwanted to be an ordinary boy
iwasnt sent to learn
to play the piano.

5 atage five istopped being a child
and became a humanbeing.
ididnt have a childhood
ididnt have toys.

6 ihad paints and brushes
at age five.
iwas already an artist
in a marseilles hotel (1947).

7 iunderstood that ihad no (fixed) address.
iunderstood that ihad no (fixed) citizenship.
ilost my country of origin.
ibecame a refugee.

The Foundation of the State of Israel from the Viewpoint of the Children
Beating

8 iarrived in israel with myparents,
 because they were jews.
 here they were told they were citizens
 but of second class.

9 Then iwastold that there were jews
 whowere of first class.
 iwashown pictures of the holocaust in europe,
 but no-one wanted to see my pictures.

10 icried, istopped eating,
 ididnt drink,
 the food was tasteless
 and the water was bitter.

11 ididnt grow,
 istayed small.
 years passed till istarted eating,
 lebeniyah and salted butter from the united states (1950).

12 father found work
 but didnt find money — hewas frightened of poverty.
 mother found work too
 to buy food for me and my four brothers.

13 theybought us food
 but the food wasnt tasty
 because they didnt understand it.
 it was preserved food.

14 igrewup, iwasinthearmy.
 then, inthearmyprison.
 iwas a humanbeing,
 iwas an idealist.

15 iwasnt suitable for the framework.
 iwasnt a national hero.
 iwas an anti-hero.
 but iremained a humanbeing.

16 igraduated from the university.
 iwent to do reserve duty in gaza (1972).
 ihad a nervous breakdown.
 ireturned into a deviant through no fault of mine

17 iwent to the art academy.
 iwas injured in a hostile action,
 ibecame a cripple in body and soul.
 ifunctioned like a man. a battered one.

18 myselfimage was injured.
 iwent to another university,
 an american university.
 ibecame a selftaughtman.

19 ibegan an artistic career.
 what they call "international",
 in new york city.
 but icontinued being ostracized.

20 iwas angry at being a refugee again.
 theylaughed at my accent american
 theylaughed at my accent french
 but no-one laughed at my accent hebrew.

21 ididnt have enough money
 to go out with beautiful women.
 imade do with dreaming about the ones
 who didnt want me.

22 the universities didnt console me.
 iwas a refugee once more.
 art didnt console me,
 only my students.

23 ibecame a professor.
 but the europeans continued persecuting me.
 theypersecuted me
 and my ethnicgroup.

24 icracked, but didnt give in.
 iasked for citizenship from a friendly country,
 ifled to america.
 and icameback to israel.

25 ifled and ireturned,
 ihated myself,
 for not attaining perfection
 for not attaining any thing real.

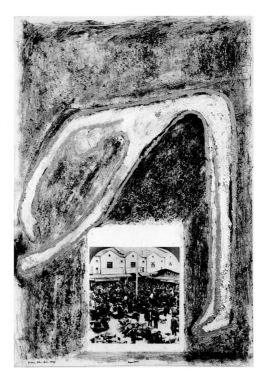

**The Foundation of the State of Israel from the
Viewpoint of the Children**
Deportation

**The Foundation of the State of Israel from the
Viewpoint of the Children**

Theodor Herzl

26 iinvest and idont attain
im a silhouette of myself.
myheart shrinks.
mybody breaks.

27 ifound consolation in cold ideas.
art and books consoled me.
mother is sick.
father is sick (1985).

28 everything vanishes.
but art is always waiting,
quietly,
indifferently, but confidently.

29 isought for my cultural origins.
itraveled to paris.
itraveled to leipzig, and then to the 16th arrondissement in paris,
icalmed down, for ifound the remnants of my family (1992).

30 iclutched at the roots of life.
my roots speak french
under the german occupation
regime in morocco (1942).

31 my memory returned to me.
istarted speaking french and hebrew.
and iremembered mother.
and iremembered father.

32 theyaccused the jew
of persecuting arabs.
the christians accused the jews
of murdering the messiah, jesus.

33 the jews werepersecuted
by the christians and the muslims,
and they by history,
things got more and more complicated.

34 killing became a science.
the science of the holocaust, stupidity and evil.
art saw and was silent
and the artists, having no choice, were too.

35 people arepersecuted.
 the jew ispersecuted.
 the christian ispersecuted.
 the muslim ispersecuted.

36 iwasforced to hate,
 but icontained myself.
 iwasforced to hate,
 but iunderstood.

37 iwasforced to hate,
 but iforgave,
 the first time, iforgave
 the christians.

38 the second time, iforgave
 the muslims.
 the third time, iforgave
 the artists.

39 now the citizens of the third world
 aretired.
 the new citizen
 is the veteran migrant, lives in hope, only.

40 what remains is memory,
 fear, and art.
 but even with a yellow patch,
 iamstill a humanbeing.

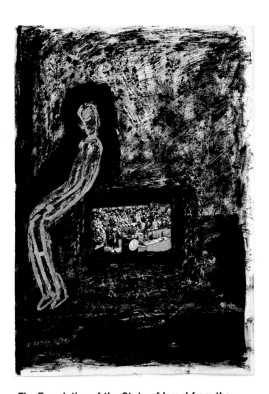

**The Foundation of the State of Israel from the
Viewpoint of the Children**
*Declaration of the State of Israel by
Ben-Gurion*

Spiritual Targets
 1988
 Acrylic, cardboard, and wood on canvas
 Collection of the artist

Rampman against a Portable Field

Some say life is the thing, but I prefer art.

Pinchas Cohen Gan

My painting *Spiritual Targets,*" Pinchas Cohen Gan once said, "reflects the political and social situation of the days during the Intifada."[1] Then he added, "Although the paintings are related to war, we are also talking about the structure visually; that's why I called it Normal Art—art that represents the life of society by the medium of painting that is not simulation, deconstruction, or post-modernism; it's just what it is." Pausing to reflect a moment, he continued, "The *Language of Art* can be related to mathematics, science, atomic [structures], figure, form, formula, and architecture, and is a continuation of *Visual Mathematics, Language Trees,* and *Logic Furniture.*[2]

Cohen Gan's progression of thought can be dizzying. But he is right. A work of art *is* nothing more than a thing, voiceless and without meaning—"it's just what it is"—until its maker and observers bring purpose to it through use. Normal Art functions as the representation of life in culture. Cohen Gan's statements suggest the rich, dense, and multiple ways by which one may gain access to the meanings the artist hopes his work will have for the viewer. His commentary also demonstrates why the restricted categories of art historical movements and styles fail to satisfy the questions his work raises.

Kristine Stiles

Confessions

Pinchas Cohen Gan

independent, contemporary, and total artist

with Commentary by Kristine Stiles

Commentator's Prologue

From the critical position of his 1994 *Confessions,* Pinchas Cohen Gan comments on his role as an artist and his position in contemporary Israeli and international art. He assigns to himself the epithet of "independent, contemporary, and total artist." *Confessions,* twelve declarations followed by explanations, attests to Cohen Gan's nagging doubt regarding the value of his artistic project, the art-historical conditions he inherited and in which he worked, and the intellectual and spiritual poverty of international culture, dominated, as it is, by theoretical formulas bereft of serious philosophical and social content. But *Confessions* also presents Cohen Gan as a self-possessed man and a mature artist who, in the middle of his life, has chosen to return to himself, to trust his sense of purpose, and to proceed in his convictions from a position of strength. Thus, *Confessions* offers a rare opportunity to witness the artist's struggle and ultimate decision to discard art-world myths and the commercial apparatus of exhibitions, publicity, and sales in order to preserve his own powerful and original voice.

The key to Cohen Gan's work is a a series of projects he called *Activities* (1972–76). These works all involved carrying out tasks that he documented with photographs and texts, and many included auxiliary objects (he made a record and a drawing for his Activity *Journey to Alaska*). Sometimes his *Activities* were strenuous, requiring great effort and transcontinental travel, as in *Journey to Alaska*; other times they were as passive as lying in a shallow trench to watch carrots grow, as in *Carrots.*

Cohen Gan's *Activities* have involved so many media and systems for making visual meaning that they defy classification. While they might be defined as conceptual art, performance, installation, or even printmaking, drawing, painting, or sculpture—all media in which he has worked—such terms cannot really summarize what is going on in this kind of off-the-wall action. But regardless of the label by which such work comes to be known, it belongs to a painterly tradition reaching from (at least) cubism to performance art. Allan Kaprow, the pioneer of happenings, has succinctly summarized this process of transformation from painting to activity: "The pieces of paper curled up off the canvas, were removed from the surface to exist of their own, became more solid as they grew into other materials and reaching further out into the room, they filled it entirely. Suddenly, there were jungles, crowded streets, littered alleys, dream spaces, people moving." [3]

Artists have been making works that resembled Cohen Gan's *Activities*— moving in, and becoming a part of the work of art—since the Futurists, who, in 1909, hurled insults at the public as a means to awaken human vitality from bourgeois stupor. The Futurists' mentor, the French playwright and cyclist Alfred Jarry, invented the concept of pataphysics, or what he called "the science of imaginary solutions," an apt description of Cohen Gan's art. Cohen Gan has created a "pataphysical" science, the elements of which are embodied in the themes of Figure/Form/Formula, that represents his imaginary solution to social, political, and cultural problems. His *Activities* and the more conventional works to which they are related, from which they emerged, and to which they returned, bear a fundamental relationship to his own personal history and the ways in which he reconstituted it as visual form into which viewers might project their own experiences.

Pinchas Cohen Gan has worked from his own experiences as an existential formula, through his art to the positions of the viewer, who then substitutes for him as a figure. In this way, he accomplishes his goal,

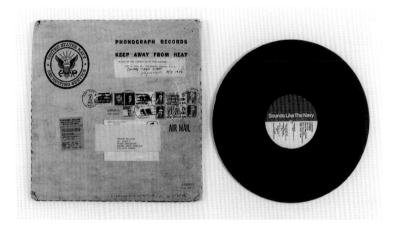

Alaska Project
 1973
 Pencil, oil pastel, and charcoal
 Tel Aviv Museum of Art

A Record: Alaska Project
 1973
 Sound wave printing on record
 Museum of Israeli Art, Ramat Gan

which is to engage art actively in the social and political environment of his immediate society and international culture. Art is the catalyst of Cohen Gan's world, the bastion from which he launches his engagement in the world at large. He uses the form of the ramp as the formula from which the figure moves both into and away from art and life. Eventually, the ramp evolves into a shelf and later a meta-position/proposition. These are simultaneously the metaphors and material objects that directly link together the variegated production that is Cohen Gan's art.

Place

Cohen Gan's *Activities* marked his entrance into, and participation in, the discourses of international experimental art. In spring 1973, Pinchas Cohen Gan engaged in an activity he called *Place*. By chiseling away varied layers of paint and plaster, he sculpted the image of an "upright figure of a man in the … wall," at the Yodfat Gallery in Tel Aviv. Next he inserted four iron pegs that permitted visitors to elevate themselves within the shadowlike perimeter of the carved-out male figure. Cohen Gan filmed some of the viewer-participants who climbed up and stood on the pegs inside his figure in the wall. Their activities contributed to the production of a two-minute, 16mm film.

In *Place*, Cohen Gan not only initiated an activity that incorporated the physical involvement of the viewer into the materiality of the artwork, but he also demonstrated the overlapping and interpenetrating responsibilities that the viewer and artist share in constructing meaning as a community that impresses "presence in matter." His reference in *Place* to class and rank is, I think, an oblique allusion to the position of the artist in the negotiation of physical space (politics) and in the articulation of social terms (culture). It is a direct comment on his own role as an artist, and particularly on his doubts about the ability of art to intervene in, and alter, the world in a valuable manner.

Nearly a year after the Activity, in a diary notation, he stated his intention in *Place*: "To represent physical and social place as a symbolic imposition of presence in matter." While this statement suggests that Cohen Gan thinks that individuals might play a crucial role in influencing political and social conditions, he also observed that any goal to change "physical conditions" was "illusory," while the production of an artwork (in this case the film) nevertheless occasioned "ceremonial …

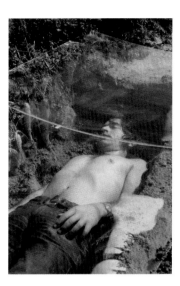

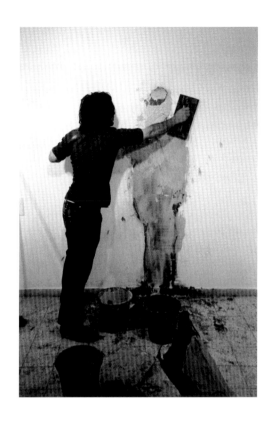

social change." Concluding his notes, he soberly commented: "The acquisition of physical/social standing is not necessarily connected with the ability to influence the environment culturally or to bring about certain qualitative changes."[4]

These notes reveal Cohen Gan's deep-seated skepticism about the role of the artist. Although they may be culturally esteemed and, thus, elevated due to their profession (ostensibly charged with making qualitative changes in their environment), artists are often excluded from directly influencing society in any fundamental way in the present, lived world of real-time politics and social change.

Like the figure in the wall in *Place*, onto which viewers project their experiences, artists have become mere icons. The artist's production is rarely acknowledged as contributing to the meaningful values and qualitative conditions of everyday life. Thus, despite their ever-increasingly complex visual and theoretical attempts to contribute to, and be acknowledged for, the construction, understanding, and transformation of the social world, artists remain trapped in/on the gallery wall. This real dilemma represents a breach between the artist's goal to contribute to society and the public's ability to view the meaning and value of that offering in real social terms.

This conundrum about the role of the artist gnaws at the core of Cohen Gan's work; it is the issue that simultaneously drives him to produce and

Clockwise from top:

Cohen Gan lies in a trench two feet deep in a carrot field of the Kibbutz Nirim to watch the vegetables grow, Carrots, 15 March 1974

Cohen Gan creating *Place* at the Yodfat Gallery, Tel Aviv, April 1973

Second confession

The second mistake of my life was exchanging my utopian, religious life for the world of contemporary, Euro-centrist, Christian, and ostensibly elitist art.

Explanation: I do not, however, identify with the avant-garde artists of the 1980s who intentionally profess an art of failure and lack of meaning. The "doctrine of failure," which attests to the "end of art," has become standard artistic composition, which has served as a means of payment in the international art market.

Commentary: *Cohen Gan's deep emotional spiritualism is cloaked and regulated in his intellectualism. He regiments his feeling through the disciplines of mathematics and science—disciplines, nevertheless, in which logic and reasoned argumentation originate in the same human capacity for intuition where art begins. Cohen Gan founded the Art & Science group in Tel Aviv (1973–75), which included pioneers in the application of technology, cybernetics, and computers to art. His formulation of* Atomic Art *emerged from his comparison of technology and aesthetics.* Atomic Art *(1982) was the term he gave a certain period of his work devoted to "building an art language based on laws of syntax, grammar, and visual representation, inspired by science and its products." Among his unpublished manuscripts on these topics are "Art & Science Project "(1973); "Art as Math-ematical Reality" (1982); and "Critical Art, Hermeneutic Model" (1988).*

constantly threatens to defeat him. It is no wonder, then, that a quarter of a century after his *Activities,* which were aimed at bringing "qualitative" change to the cultural environment, Cohen Gan came to the conclusion that life and art are incommensurable. "Some say life is the thing," he wrote in 1994, "but I prefer art." For Pinchas Cohen Gan, art is the place where he is most free to be himself.

The idea that art and life are separate and distinct is as old as aesthetics and as new as the goal of artists throughout the twentieth century to fuse them. For the past few decades it has become increasingly fashionable to talk about the political resistance, intervention, or transgressions of art. But the compelling meaning of Cohen Gan's "propositions"—the term he uses to describe his paintings, constructions, and *Activities*—is how they do not posture with politics; instead, they effectively operate within a domain where change in real experience produces an alteration of thought. Operating as a visual guide between an individual's emotional and conceptual spaces and the sweep of social existence that is called "life," the work of Pinchas Cohen Gan makes visible, and links the otherwise invisible, interstices between the analytic determination of a finite material world and the infinite reaches of independent intuition and mind.

Rampman against a Portable Field

A photograph of Cohen Gan's Activity *Biography/Range of Adaptation* (23 June 1974) shows a spare series of geometric shapes of metal tubing with a tape recorder and microphone suspended from one element. These forms rest on what appears to be a pebbled ground against a backdrop of undulating forms. Both the foreground and the background are virtual abstractions against which the geometry of shape marks an ingress into the work. Spare in its visual geometry and conceptual in its intent, the work depicts objects on a ground that can only imply the production of a sign signifying human activity.

As his starting point for *Biography/Range of Adaptation*, Cohen Gan selected the intimate environment of his own personal living quarters. He measured the distances between the objects in his room and then translated these measurements into abstract geometric forms made of lead piping, 10 millimeters thick, with moveable joints. Having measured the space within which he carried out his life, the space of the matter

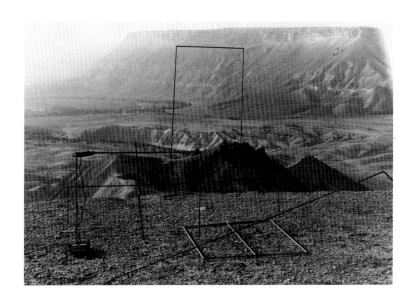

surrounding him (impregnated with his presence), he installed the spare geometric sculptures in, and against, the Negev Desert, the backdrop to his life. He also calibrated these geometric forms (and their measurements) in relation to a personal cosmology of the temporal periods he had spent in the "significant places" in his life: six years in the country of his origins, Morocco; fourteen years in the place of his maturation, Kiryat Bialik; and finally, twelve years in Jerusalem.

While the personal information about Cohen Gan's life is intrinsically significant to *Biography/Range of Adaptation*, it is also linked visually to later works. The figure/ground relationship he establishes in the photograph of the sculptural installation on the Negev Desert operates like the ramp on a portable field in *Rampman against a Portable Field* (1977), a work that I think is a key to Cohen Gan's propositions.

Rampman against a Portable Field consists of seven monochrome panels against which the artist placed a ramp. One image of the work shows the abstract monochrome painting with its adjacent ramp against the gallery wall. In another image of the same work, Cohen Gan himself enters our field of vision, appearing as a man against his portable field. In the photograph with the artist, the portable field—namely the painting— is shown to be the framing device of the artist, a mechanism portable enough to be used as the ground for any subject Cohen Gan wishes to observe. Yet while the artist may insert himself into the visual field, the photograph refers less specifically to Cohen Gan's own life and more

Biography/Range of Adaptation installed in the Negev desert, 23 June 1974

generally to any figure who metaphorically enters the field. Thus, the artist's figure becomes an abstraction, a formula against the portable field, able to function merely as a representation of any viewer who might engage the work.

In *Rampman against a Portable Field,* Cohen Gan represents human experience in the image of the *figure,* while the function of art—to make and remake *form*—operates as a symbol—*formula*—through which meaning is communicated. But transitions between figure, form, and formula—the theme that animates Cohen Gan's entire production—are fluid in his work. His activity as an artist (figure) provides the basis for his intervention (form) in the world of varied and abstract meanings (formula). In this regard, an Activity such as *Biography/Range of Adaptation* must be understood as interconnected with the paintings and constructions such as *Spiritual Targets.* They are connected in the manner in which they translate social space into a target for the spiritual transformation of individual life (biography).

Returning to *Biography/Range of Adaptation* and *Rampman against a Portable Field,* the relationship between the object and its ground (the sculpture on the Negev Desert and the ramp placed against the ground of the monochrome painting), becomes—when Cohen Gan enters the field—a figure on a ground between which a ramp mediates as the point of entry into the field. In this subtle but important shift, Cohen Gan— through the device of the ramp—creates a relationship between figure (himself), form (the ramp as the metaphor for art), and formula (the abstract representation of a field). In *Place,* when the visitors to Yodfat Gallery stepped onto the pegs, they made Cohen Gan's Activity their activity. They became figures on the form. The pegs that operated like a ramp between the world of the spectator and the world of the object, the field, or formula of the shadowlike shape of a man carved into the wall.

Cohen Gan's artworks represent intimate aspects of his own life, but they do much more. By translating the classical figure/ground relationship of conventional art into his own vocabulary, he provides a point of transition—the ramp and the peg—that articulates the space between the viewer and the artist, and thereby, invites viewers into the field the artist has created, where their experience becomes paramount. In this sense, Cohen Gan's works operate as a visual structure, a point for the departure of personal history, and a transition point into and through the social world of the observer.

Third confession

The third mistake of my life is my belief that art and science are universal in their essence and that a structural connection exists between them.

Explanation: To date, I have written six theoretical books on the science of art. My intention in writing these books was to preserve my sanity, on the one hand, and to conduct a dialogue with the centers of high art in Europe and America, on the other. Some ten years passed before I became aware of the fact that the group of believers in high art is dead.

Commentary: *Cohen Gan believes in high art in the sense that he knows art is always alive and has a higher purpose, which is to comment on, and perhaps qualitatively alter, the world.*

Fourth confession

In yuppie vernacular, my efforts to reach perfectionism in art testify to my spiritual inferiority. I should have understood long ago that I don't have to impress anyone, since society has betrayed its artists.

Explanation: We learn from history of at least two opposite incidents of success—one later example and one earlier example. The first, Marcel Duchamp, carried the banner of incidentalism; while the second, Jeff Koons, believed in the ordinary and the banal.

Commentary: *French philosopher Henri Lefebvre has also noted that "Western philosophy ° betrayed the body: It has actively participated in the great process of metaphorization that has abandoned the body; and it has denied the body." The question then must be whether art, the systematic metaphorization of culture, is part of the structure of culture responsible for betraying the body. See Lefebvre's* The Production of Space, *trans. Donald Nicholson-Smith (Oxford, England and Cambridge, Mass: Blackwell, 1991).*

Cohen Gan's diary notes to *Biography/Range of Adaptation* (30 June 1974) suggest that his thinking had already moved far beyond the idea of discrete autonomous works of art and into the portable field of the political terrain of social life: "This action sums up the total of the places where you have been in your lifetime; each life-section is defined and influenced by the place and the time, but also by the accumulation of experiences of previous life-sections. The disposal of the objects over the area enlarges the territory in which you live but makes it more abstract. The transitions from place to place raises the question of your adaptation to a new situation whose main components are life itself and technology. The mutual relationships of these components are not permanent."[5]

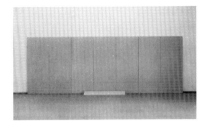

The Imposition of Presence in Matter

Most of Cohen Gan's propositions provide a visual form (a portable field) for a situation between the interiority of the artist's imagination and the actual experience of the viewer. Some works move the viewer back and forth between Cohen Gan's own conceptual and biographical space to that of the viewer's place. Others frame this portable field in terms of the local and international landscapes of politics.

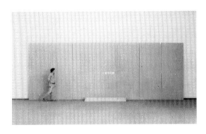

In *Transfer of the Studio to the Gallery* (1975), a work that was installed in Old Jaffa, now a suburb of Tel Aviv, Cohen Gan again calibrated the space of his own intimate living quarters by measuring the shapes of all the furniture in his room. He then had wooden armatures that represented these shapes built to scale, and he installed them in a mixture of "bricks" composed of cement and straw—the very unstable materials used in the makeshift constructions of refugee camps. In part the installation grew out of his feelings about the Yom Kippur War.[6] But it was directly inspired by his *Action in the Jericho Refugee Camp* (10 February 1974).

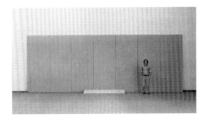

Rampman against a Portable Field
1977
Acrylic and plywood
Seven panels, 761/4 x 301/2 each
Destroyed 1983

Action in the Jericho Refugee Camp took place at a refugee camp in the northeastern sector of the ancient city of Jericho, where he constructed a temporary shelter and gave a lecture on the subject of the conditions for peace in Israel "in the year 2000." This question was, for Cohen Gan, both spiritual and physical because, as he later noted: "The legal attitude towards establishing who is a refugee and/or the United Nations definition of a refugee make no difference to the refugee's actual existence and feelings about the territories where he was or has passed."[7] *Transfer of*

Fifth confession

The artist of the future, in the tradition of Simulacra, with which artists are so taken today, will apparently be a CNN announcer: He sees nothing, but everyone sees him.

Explanation: The curators in Israeli museums claim that Israeli artists are creating art in the tradition of Western art. How is it, then that our artworks are not hanging in the Louvre, in the British Museum, the Prado, the Uffizi Gallery, or the Museum of Modern Art in New York?

Commentary: *Israeli artists are caught in a paradox. They are not exhibited if they* do *make art that "looks" like it has been done in the West; and they are not exhibited if their work looks too provincial, i.e. if it does* not *look like what has been done in the West. This is a problem of colonialism.*

Ruth Beesch and I traveled to Israel three times to work on this exhibition. Everyone spoke about his or her sense of Israel's status on the "periphery." Cohen Gan's remark on this subject haunts me: "This is terrorism. If you don't come to Israel, we will be in a prison camp! You have to keep coming so we are not cut off." I have heard similar comments in Romania.

the Studio to the Gallery reflected Cohen Gan's meditation on what it meant to be "in a continual state of being a refugee" himself. "A refugee," he has declared, "is a man who cannot return to his birthplace." In *Transfer of the Studio to the Gallery*, he installed the abstract shapes of the sizes of his furniture on a ramp that invited viewers to imagine a walkway into the situation represented. The installation of the ramp (the form) united the perception of the spectator (the figure) with the problem of the refugee (the formula).

The figures of the refugee and the emigré appear prominently in much of Cohen Gan's work. Indeed his own pervasive sense of aloneness as an emigré is clearly suggested in the formal isolation of the figures in his paintings. They offer yet another different perspective on the meaning implied in *Transfer of the Studio to the Gallery* and *Action in the Jericho Refugee Camp*. In *Figures 1-59* (1977), for example, tiny little cut-out people in various physical activities float unanchored in chromatic space. The disembodied figures are dwarfed by formulas in *The Auxiliary Sample[3] Derivations of the Perfect* (1976) from his series *Language Trees*.

Such schematic representations express a sense of being foreign in a "foreign location," the term he used in his first one-person exhibition, *Exhibition of Etchings in the Cowshed of Kibbutz Nirim* (February 1972). There the term described his intention to give spectators "a feeling of estrangement" in relation to their ordinary surroundings. He accomplished this by displaying twenty-two etchings in a single row over the cows' mangers on the "regular route" of the kibbutz members, a site accessible twenty-four hours a day. This "feeling of estrangement" was equally related to what he identified as "the question of my origin and cultural surroundings." Such a question prompted him to call this exhibition a "self-portrait," and indeed it is.[8]

That *Exhibition of Etchings in the Cowshed of Kibbutz Nirim* might be a self-portrait—in the same manner as *Transfer of the Studio to the Gallery* is both a picture of the abstracted interior of Cohen Gan's private domestic condition, and the refugee's stark reality—is unexpected in the history of art and the conventions of self-portraiture. But artists throughout the twentieth century have searched for more immediate ways in which both to experience and to express the interrelation between their context, the construction of their identity, and its transmutation into visual form.

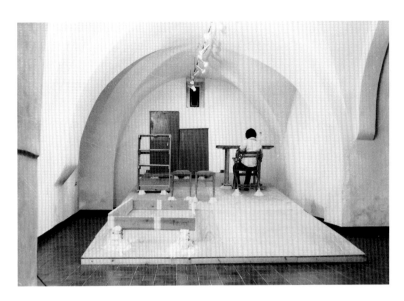

Jackson Pollock, for example, spoke about his personal motivation for making painting into an activity (what art historian Harold Rosenberg dubbed "action painting"), a kind of self-portraiture. Pollock discussed the impact that transgressing the discrete boundaries of painting had on his emotional state: "On the floor I am more at ease. I feel nearer, more a part of the painting, since this way I can walk around it, work from the four sides and literally be in the painting....When I am in my painting, I'm not aware of what I'm doing....I have no fears about making changes, destroying the image, etc., because the painting has a life of its own. I try to let it come through."[9]

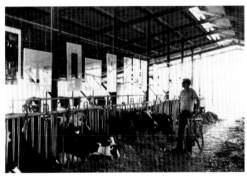

In the sense that being in the work of art permits something of the artist to "come through," Cohen Gan's *Transfer of the Studio to the Gallery* might be considered not only a self-portrait but a national self-portrait that invited the problem of the refugee, the emigré, to "come through" the social discourse of Israeli society in 1974. *Journey to Alaska* might equally be understood as a national self-portrait, a reading that Cohen Gan's diary references to it justify: "To travel to some environment in which everything is different, the opposite of your environment. To travel from one end of the earth to the other, to reach your own end, the end of geography."[10] *Carrots*, too, might be considered both a self-portrait and national self-portrait in the sense that the trench in which Cohen Gan lay to watch the vegetables grow might equally be understood as a sardonic commentary on what it means to live in the destruction and death that

Installation View of *Transfer of the Studio to the Gallery*, Old Jaffa, 1975

Exhibition of Etchings in the Cowshed of Kibbutz Nirim, 1-12 February 1972

Sixth confession

As the creative life of the artist in the state of Israel is plagued by political, religious, and social conflict, he is compelled to be actively involved as well as to pursue aesthetic and artistic activities in his private studio.

Explanation: However, if you were to ask the Bishop of Jerusalem or the leader of the Front Nationale in France, he would most certainly tell you with great confidence that Jews have no aesthetic sensibilities.

Commentary: *For a superb book on the subject of anti-Semitism and racism, see* The Jew in the Text: Modernity and the Construction of Identity, *ed. Linda Nochlin and Tamar Garb (London: Thames and Hudson, 1995). Cohen Gan is not the only artist who has discussed the problem of incipient racism—what some preferred to describe as classism—in Israeli society between Sephardic and Ashkenazi Jews.*

Seventh confession

I have been disappointed numerous times by the art world, yet while I am actually creating, when law is revealed and nature is purified of the minutiae, I am happy.

Explanation: Despite it all, avant-garde artists in Israel believe that they are creating pure art in the spirit of international modernism, despite the fact that some of their artworks relate to the place of their creation, here and now.

Commentary: *The level of art production in Israel is extremely high with much experimental work in all media. Most of contemporary artists are extremely well informed about the international art scene and are more interested in aesthetic issues related to postmodernist discourses than in "international modernism."*

constantly threaten Israel.[11] In this sense, works such as *East West Erosion Figure* (1977), *Figure, Form, Formula; Jerusalem Post* (1977), and the recent heroic series *The Foundation of the State of Israel from the Viewpoint of the Children* (1996) are not only portraits of a person, but pictures of a time and a nation under siege. They recall many of Cohen Gan's *Activities* and installations, but none more poignantly than *Transfer of the Studio to the Gallery,* and they testify how this emigrant, Pinchas Cohen Gan, not only worked for his country but attempted to heal and reconstruct his own psychic formations.

Despite Cohen Gan's passionate commitment to society and to art, I can never look at his figures—or the photograph of his installation *Transfer of the Studio to the Gallery*—without thinking about his biography, his painful experience, his deep lack from his sense of not belonging in Israel as a dark-skinned Sephardic emigrant from Morocco in a land dominated by light-skinned German Ashkenazis.

By his own testimony Cohen Gan has often experienced racism. It came to a peak in 1993 when he resigned from his post at Bezalel Art Academy in Jerusalem after overhearing a comment made by a long-time colleague that suggested that he got his teaching position only because of the Art Academy's need to fill a quota for Sephardic Jews. This incident led to Cohen Gan's attempt to instigate reform in the educational system by authoring an "International Petition for Reform of Basic Principles of Higher Education in Israel" (1 September 1993). This petition calls for "fellow creative artists" to help work for reform in the educational and cultural system. The aim of this reform was "the aspiration of peace and equal opportunity in higher education [that] will create humane and social equality in the hearts of the nations of the region and of Israel."[12]

Such an ecumenical point of view to the entire region reflects Cohen Gan's own emigré status, as is most powerfully expressed in his dedication to his massive compendium of images, symbols, and texts—*Dictionary of Semantic Painting and Sculpture* (1991): "Dedicated to all Jews and non jews alike, who survived the persecution and expulsion by both Islamic and European countries from 1492 on. Dedicated to all victims of the European holocaust during the second world war, Jews and non-Jews alike. Dedicated to all uprooted human beings, separated from their families and banished from their land for political, religious or racist reasons, in flagrant disregard of fundamental human rights and freedom of expression in the spheres of science, literature and art."[13]

East West Erosion Figure
 1977
 Synthetic high-gloss enamel, collage, and torn newsprint
 Tel Aviv Museum of Art
 Gift of the artist

Eighth confession

People speak of the end of art and the end of painting, yet it seems that art and painting have not died.

Explanation: Art creates an illusion of the present; it uses painting as a camouflage technique to describe a metaphor. This is possible because it is so standard and so familiar to the audience.

Commentary: *Cohen Gan is a master of camouflage, and he uses metaphor to mask his strategies of survival. His studio is filled with literally hundreds of paintings and constructions stacked three and four deep against the walls. Neatly arranged folders made of recycled cardboard, holding hundreds of works on paper, are piled high on every table and flat surface. Bookshelves overflow with collages, artist's books, catalogs, and more. Cohen Gan is embarrassed by his productivity and tries to hide his work. When I visited him, I continually lifted up the corner of folders, peeked in bookshelves, turned works around, and nudged him to let me see more work. "If you make all this work," I prompted him, "you must want to show it to someone!" Initially he responded evasively to my onslaught. But my outlandish intrusiveness—a behavior I adopted when I noticed it amused him—was rewarded with a sly grin and compliance.*

The racism Cohen Gan experienced in Israel followed him to the United States, where, while participating in the exhibition "Seven Artists From Israel" in Los Angeles, he received the following letter (26 November 1978). I reproduce it in full with its grammatical errors intact:

> How you dare to come to our Christian country to say that: "UNITED STATES and israel are the same". Jew you must be insane. Only a jew has four nationalities, you know why—because you belong nowhere....... all of you are parasites, you are rats of the world, always running from one part to other staying nowhere Don't judge USA by NY, LA or Chicago, , very soon something is going to happen here and we will be free of all you jews. The Magnum force is on the way, that's for sure. We dont need jewish artists, we have very good ones right here and we protest jews using our Museum for two long months. Go SOB jews show your art inside of the synagogues where you belong and while they exist. We hate you jews KKK[14]

This letter painfully reminded Cohen Gan of a name, "parasite," he had been called in 1961 when serving in the Israeli army:

> I was in the army, standing at attention, and there was a declaration by the Chief of Staff about the victorious military situation in Sinai.[15] I said, "No, it wasn't a victory, it was a mistake." The commander said, "What did you say? What! You go to jail. You are bad. You are nothing. You are a political parasite." They took me to an army trial and put me in jail for 30 days. Just for saying this statement. Nothing else. I couldn't believe it. It was the most degrading situation. I was a pig. 19 years of age: they shaved me and put me in that cage with 40 people, 40 people! My job was to work on the mountains for 40 km each day. I had shoes without shoe laces, so my feet got blisters and hurt. So I had a hard time in the jail. Since then they lost a soldier. Since I entered the prison, I lost interest in the army.

The Israeli Army may have lost the soul of a soldier, but Cohen Gan remained in the army and the reserves, where, while serving in 1972, he had a nervous breakdown:

> I was a night guard in a refugee camp in Gaza. During the night at one or two o'clock, I heard the guards torturing someone. I couldn't stand it. I started to cry and shout all over Gaza: "Hey! Why? Stop it! I can't stand it!" They came to see what happened to me. I went crazy listening to them torture the Arab. They took me to the hospital. I wrote to the Minister and other officials about the torture. For me it

was the most terrible thing in my life, even worse than the bomb. This was really unbelievable. I didn't know that things like this could happen. After the breakdown they told me not to worry about anything, I'd be fine and I could continue in the reserves. I served in the army 25 years. But I'm telling you, I'm not a fighter. They just wanted me there, to be around.

Is it any wonder that Cohen Gan is preoccupied with elements of biography, or that it appears in works such as *Transfer of the Studio to the Gallery,* which considers problems of identity and its relation to location and history?

The focus of Cohen Gan's lifetime of work has become, in recent years, the primary discourse of post-colonialist and diasporic studies. As cultural anthropologist James Clifford has noted: "An unruly crowd of descriptive/interpretive terms now jostle and converse in an effort to characterize the contact zones of nations, cultures, and regions: terms such as *border, travel, creolization, transculturation, hybridity,* and *diaspora.* … The term…that once described Jewish, Greek, and Armenian dispersion…will not be privileged in the new *Journal of Transnational Studies* and now shares meanings with a larger semantic domain that includes words like *immigrant, expatriate, refugee, guest-worker, exile community, overseas community, ethnic community*."[16] But twenty-five years before the new *Journal of Transnational Studies* was launched, or before Clifford wrote, "Diasporas," Cohen Gan translated his personal experience into images that could communicate painful knowledge, wisdom that may now be theorized as "semantics" in academic discussions.

At the beginning of this text, I wrote: "Cohen Gan's 'propositions"… do not posture with politics; instead, they effectively operate within a domain where change in real experience produces an alteration of thought…a visual guide between an individual's emotional and conceptual spaces and the sweep of social existence." His diary notes to the Activity *Touching the Border* (7 January 1974), provide proof of his prescience: "A border is marked on maps as an internal line, and its marking is a visual graphic sign. The limit of our strength is not a geographic border but a cultural border, a border between cultures, the distance between them being much greater than the geographical distance. *Touching the Border* is purely spiritual meaning and posing a

Ninth confession

The essence of the crisis regarding the end of art lies between the perception of art as futility and the perception of art as a language.

Explanation: Those who claim that art is futility believe that their sole function is to commit sins against the language and then to atone for those sins. Those who claim that art is a language deal with the correlation between words about words, words about things, things about words, and things about things. In summary, art is an activity that has a religious and scientific nature; it is not a doctrine.

Commentary: *Amen!*

question."[17] Cohen Gan has been a visual pioneer of post-colonial and diaspora thought alerting us to, and connecting us physiologically with, our most profound emotions and perceptions, experiences that will eventually become semantic orientations. Indeed, his art has prepared the ground of mind through the body of sight; it takes time for the mind to grasp what the body knows.

Cohen Gan's body knows what it means to be estranged and damaged. Such works as *Bandaged Figure* (1968), an early photo-etching embossment on paper, metonymically conveys that experience. Cohen Gan was injured by a terrorist car bomb that killed numerous civilians in Jerusalem in 1968. The explosion knocked him to the ground unconscious, wounding him and covering him in rubble. This experience made Cohen Gan an official "Invalid of a Hostile Action," and led to his inability to "continue in my macho stuff." As he told me, "I couldn't fight." In *Orphan's Kaddish,* this simple statement becomes a lament: "iwasnt suitable for the framework. / iwasnt a national hero. / iwas an anti-hero. / but iremained a humanbeing....ireturned into a deviant through no fault of mine." The deviant, for Cohen Gan, is the anti-macho, anti-hero who does not fit the framework.[18]

The heightened awareness of the politics of space and technologies of division and their relationship to survival that are the subjects of *Transfer of the Studio to the Gallery* eventually became the source for Cohen Gan's more detached, cerebral orientation to art and to history. This direction is already forecast in a statement he made about his activity, *Dead Sea Project* (Autumn 1972–Spring 1973). There he noted obliquely, "As life and salt exist in inverse proportions, the possibility of the existence of life decreases the further it is from the source."[19]

This statement is simultaneously a direct comment on the physiological conditions of the Dead Sea and Cohen Gan's response to "the launching of the first satellite, which upset the relationship between man and his natural environment." But it is also the antecedent for a more detached position, one that could conceptually move beyond the conditions of survival in Israel and one that could more directly connect with the direction of international art and distance him from the immediate political implications of his *Activities.* He understood this new position very clearly and wrote about his "need to demonstrate the subject

[which] is now an environmental one and is no longer limited to our area alone." He carried the structural support for the *Dead Sea Project*, a ramp he built from which to launch a boat into the Dead Sea, with him into his new work. Significantly, in his diaries, he refers to this ramp and the boat it would launch as vehicles that "mark the route of life (not carried out)."

But Cohen Gan did carry out the route his ramps suggested. That journey was vividly and successfully paraphrased in art that permitted the spectator to map his or her own personal and national identity onto the works and, thereby, bring meaning into the social environment of political exchange. Such a claim is never better substantiated than in an examination of the now popular and widespread discussions of the post-colonial subject, the theme Cohen Gan explored in questions raised not only in his *Activities*, but in the moving images of his figural paintings.

The Visual World of Pinchas Cohen Gan

If the "deviant," for Cohen Gan, is the figure of the anti-macho, "anti-hero" who does not "fit the framework," the question remains: How does one get into the frame? What is the frame, and does Pinchas Cohen Gan fit it?

The frame, of course, is art. During the mid-1970s and throughout the 1980s, Cohen Gan seemed to retire to its "safe haven."[20] Although he maintained a sustained dialogue with the problems of art, the social and

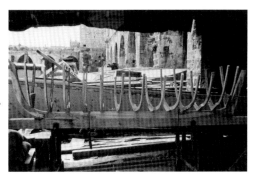

The skeleton of a boat built from eucalypyus wood for the *Dead Sea Project*, Autumn 1972–Spring 1973

Ramp (structure) built in the Dead Sea to launch the boat (not carried out) for the *Dead Sea Project*, Autumn 1972–Spring 1973

Tenth confession

The future typology for the new descriptive language of reality is as follows: Natural language—a meta-language—the natural language object of a new meta-language.

Explanation: We will distinguish among the three levels of reality that reflect the concept of realism:

1. The natural stage: In which nature is a physical experience

2. The artistic stage: (Artificial) In which the creation of art is based on imitation

3. The cultural stage: In which reality is dictated according to definitions anchored in the social myth

Commentary: *Cohen Gan's continual creation of new doctrines contradict his Ninth Confession, above. His schema are modes of comparing his own aesthetic developments with the constantly changing conditions and representations of the art world. His natural, artistic, and cultural stages are akin to his formulation Figure/Form/Formula, the animating concept of this exhibition.*

political questions that haunt his life became increasingly less direct and vivid in his work—except, of course, when his "safe haven" was hit by something like a scud in downtown Tel Aviv. In such intense moments, Cohen Gan released his expressive side. How else can one account for the coexistence of such lyrical, cool, and analytic paintings as *Coefficients of Painting, Sculpture, Drawing and Architecture* (1978) and the dark brooding Dionysian anger of *Drawing of Lebanon War* (1982)? Similarly, in the early 1990s, he countered aloof Matisse-like blazes of color mixed with exquisite design in the series *Logic Furniture* with the explosive raw brutality of *11/2/91: Aouto-da-fe* (1991) .

Negotiating the minefields of his own *oeuvre*, Cohen Gan has moved back and forth between visual styles, art-historical movements, and intellectual and emotional responses, through modifications of Figure/Form/Formula. In New York in the mid-to-late 1970s, his ramp transmogrified into a shelf—"something you can fill with many ideas." In *Shelf* (1976), a pale blue shelf cradles a panel, providing actions between the viewers' space and the space of the painting.

Something similar occurs in Cohen Gan's numerous "non-Euclidean" works, which have a kind of abstract figurative identity of their own. Vestiges of ramps and shelves continued to abound even in the 1980s, when Cohen Gan appeared to have all but abandoned the hard-edged monochromatic constructions and sculptures of the 1970s for gestural, painterly, figurative works.

Still, in such constructions as *Language of Art* (1988), ramps and shelves articulate space as propositions that throw into question the differences between painting, sculpture, and architecture, and recall a comment by Donald Judd in 1965: "Half or more of the best new work in the last few years has been neither painting nor sculpture....The new three-dimensional work doesn't constitute a movement, school or style [because] the common aspects are too general and too little common to define a movement."[21]

Judd's observation was even more pressing thirteen years later, when Sheldon Nodelman, writing on the works of Brice Marden, David Novros, and Mark Rothko, observed: "It is vain to attempt to allocate or prescribe exclusive modes of operation to hypostatized categories of, e.g., "painting" or "sculpture"; rather any particular artifact will play upon and emphasize certain possibilities of pictorial/sculptural (or other)

functioning. The proper role of an analysis involving the discrimination of sensorial modes is in the identification and assessment of this complex transactional process.)"[22] These are the languages of art that compelled Pinchas Cohen Gan, and to which he responded in a vast array of works.

The necessity of considering the transactional process between the object, the spectator, and the context, meaning, and very purpose of the work was never so important, perhaps, than precisely during this period of the early 1980s, when the "end of art" was so confidently proclaimed.[23] Cohen Gan's work was deeply engaged in this discussion, and is one of the few sustained commentaries anywhere in the international scene of art that successfully operates between the difficult aesthetic and cultural problems raised by combining activities, objects (painting, sculpture, and architecture), and theory—words, symbols, and things—in the same body of work. His success has much to do with the flexibility of his model— Figure/Form/Formula—and the mechanisms he used for negotiating that model: the ramp, the shelf, and finally meta-theory.

Cohen Gan, like many artists of the period, became increasingly involved in writing theory in the 1980s. He created a meta-language that permitted him to situate art as a psychic event on par with other disciplines that had not—yet—been proclaimed dead, and that still commanded the respect of the public and artists: mathematics, science, and linguistics. In his writings, like a postmodern kabbalist, he analyzed such highly coded cultural objects as the Bible in terms of the logics of grammar and the semiotics of sign systems. He produced such visual texts as his *Bibliae Principia Descriptiva* (1989), an arcane, esoteric, unpublished treatise on subjects ranging from "Belief and Public and Private Morality" to "Belief in God, and the Work of Art" and illustrated with lavish drawings of figures in relation to various schematic representations of objects, maps, and other visual signs. This is also the period of Cohen Gan's *Atomic Art*. Such eccentric works as *Document Carrier Input Unit* (1988), *CDC 915 Parallel Photocell Scanning System* (1986), and *Alphabetique—l'objet, c'est oeil* (1995), are paintings and constructions that present visual schemata, meta-pictures that are abstractions of life—lived elsewhere.

Eleventh confession

In conclusion, a slightly more personal confession: It is amazing to see and examine the nature of modern man who lives in the large metropolitan centers of Europe and America. Like the contemporary artist, he is graced with an inclination toward imitation, plagiarism, and the stockpiling of philosophical and artistic ideas.

Explanation: Since the year 1970, people such as these have ridiculed my ideas, proscribed my books, and ostracized my art, after which they began to hoard them quite naturally as if they were orphans.

Commentary: *Artists internationally express similar persecution complexes. Cohen Gan would be the first to admit that borrowing is common in art, and always has been, long before the 1980s with the advent of Baudriallardian simulation and simulacrae, which made appropriation de rigeur.*

Twelfth confession

Soon the Dalai Lama (the exiled Tibetan leader) will arrive in Israel. In honor of this event, Israel television aired a five-minute broadcast, on March 11, 1994, at 9:00 p.m. of his words. The leader claimed, among other things, that man begins his life with a basically good nature, yet the Bible maintains that man's basic inclination from his early years is evil. Who is right?

Explanation: The Dalai Lama has read the Bible and has met Joseph Beuys, yet he sells the media what it (and the audience) wants most. As for me, I believe that while each individual is good, he becomes a beast once he joins a larger system. This apparently also holds true for the art world.

Commentary: *Cohen Gan's enormous capacity for irony is clear here in the link he makes between the Bible and Joseph Beuys, the sole artist in the post-1945 period to be canonized in a quasi-religious manner.*

When I asked about these works, Cohen Gan conceded: "Meta-language helps me to protect myself from pop art and high art." In other words, he could enter the frame and participate simultaneously in the social intercourse of a fully cybernated culture, inebriated with its linguistic constructions and language games, only if he appeared to depart from the high ground of "high art" (which he still believes has a purpose to alter "qualitatively" the cultural environment). His "meta" position allowed him to do so. Thus, what was the ramp (into and between art and life in the early 1970s) became a shelf that, in turn, became a meta-theory, a meta-art (in the mid-1980s and into the 1990s), which enabled him to comment from afar as he continued to operate between categories near the emotional and intellectual center of art and his life.

Today, Cohen Gan says that his metaphysical formulae "no longer count," because he has returned to "analyze my situation." In this regard, his *Confessions* (sidebar) are a powerful testimony to, and about, his immediate situation. Art remains at the center, but the spiritual values he submerged in a meta-discourse have returned in a more direct commentary on life. Such is the power of a series like *The Remaking of History* (1996), whose title might serve as the *leit motif* of the visual world of Pinchas Cohen Gan.

Art activities are solitary. But they require enormous energy and stamina, energy that is movement, the motion that shapes change, change that is a passage, an inclination to, or a ramp from, somewhere to something metaphysical or actual. Art is an act of progress, a shelf from which to reconsider the world (for better or worse). We are alone in our mind with thoughts whose ideas are connected to fingers that make. The energy of the maker is one of response, an answer that is also an initiation, an "imaginary solution" to the struggle that is life. As Pinchas Cohen Gan declared, "Art kept me alive."

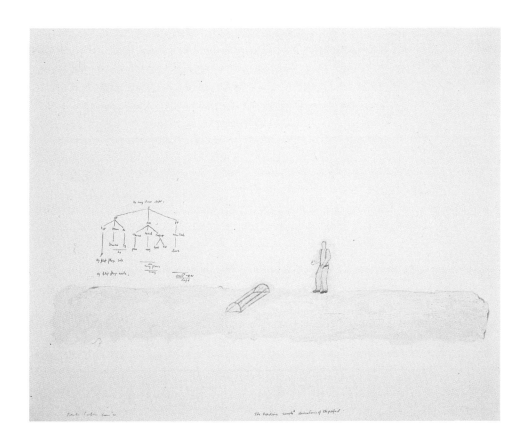

The Auxiliary Sample³ Derivations of the Perfect
 1976
 Felt pen, oil, and graphite
 Collection of the artist

I would like to take this opportunity to thank all the patrons who have supported me and my creative work up until today. — Pinchas Cohen Gan

Notes

In addition to Cohen Gan, there are many people that I would like to thank. Ruth Beesch has provided expert vision, direction, guidance, and generous friendship that brought this exhibition into being. Denise Dickens, director of City Gallery of Contemporary Art, in Raleigh, initially involved me in this project. I want to thank the following Israeli artists—Aya and Gal, Gideon Gechtman, Uri Katzenstein, and Zvi Goldstein—from whom I gained many insights that found their way into this text, and art historian Sergio Edelsztein, one of the most perspicacious minds in Israeli art, for his thoughtful comments on our work and for his friendship. I want to thank Edward Allen Shanken for his support.

1. Attacks by Arabs on Israeli settlers and by Israeli settlers on Arabs escalated in 1987. Large-scale riots and demonstrations broke out on 9 December 1987 and continued for months thereafter. This uprising became known as the "Intifada," which literally means "shaking off."

2. Unless otherwise noted, all quotations in this essay are from taped but unpublished interviews I made with Pinchas Cohen Gan on three separate trips to Tel Aviv in October 1994, June 1995, and March 1996.

3. Allan Kaprow, *Assemblage, Environments and Happenings* (New York: Harry N. Abrams, Inc., Publishers, 1966), p. 165.

4. Yona Fischer, *Pinchas Cohen Gan, Activities* (Jerusalem: Israel Museum, 1974), p. 40. Hereafter, this catalog is cited simply as *Activities*.

5. *Activities*, p. 34.

6. This war began on the holiest day of the Jewish year, the Day of Atonement, 6 October 1973. Israel was taken by complete surprise by an attack from Egypt and Syria that shocked its sense of security. See *A History of the Jewish People*, ed. H. H. Ben-Sasson (Cambridge: Harvard University Press, 1976), p. 1087.

7. *Activities*, p. 36.

8. Ibid, p. 44.

9. Jackson Pollock's statement in *Possibilities I* (Winter 1947–48): 79, reprinted in *Theories of Modern Art: A Source Book by Artists and Critics,* ed. Herschel B. Chipp, Peter Selz, and Joshua C. Taylor (Berkeley: University of California Press, 1968), p. 546.

10. *Activities*, p. 38.

11. I would like to thank Edward Allen Shanken for his contribution to my thinking on the relationship between nationality, self-portraiture, and national self-portraits in his work on Constantin Brancusi's *Pasarea Maiestra*. See Shanken's forthcoming essay, *"Le Coq, c'est moi!"*: Brancusi's *Pasarea Maiastra*: Nationalist Self-Portrait?" in *Art Criticism* (1997).

12. See Pinchas Cohen Gan's unpublished "International Petition for Reform of Basic Principles of Higher Education in Israel," 1 September 1993.

13. Pinchas Cohen Gan, *Dictionary of Semantic Painting and Sculpture* (Jerusalem: Bezalel Academy of Art and Design, 1991), p. 525.

14. Unpublished letter to the artist.

15. In 1956 Israeli made retaliatory attacks on Egypt at Kalkilya (10 October) and at the Mitla Pass (29 October) when it invaded Egypt for blocking the entrance to the Gulf of Aqaba, an invasion that resulted in the occupation of the southern tip of the Sinai Peninsula and the end of the Egyptian blockade on 5 November 1956.

16. James Clifford, "Diasporas," *Cultural Anthropology* 9, 3 (1994), p. 303.

17. *Activities*, p. 36.

18. To this day, Cohen Gan is still uncomfortable with the experience and seemed to need to prove something about it. He produced a photocopy of the letter of 5 December 1968 he received from the mayor of Jerusalem, the Honorable Teddy Kolleck, who wrote of the artist's wounding in the "criminal attack in the zone of Hahane Yehuda" and wished him a quick recovery and "return back to normal life."

19. *Activities*, p. 43. All of the following quotes on *Dead Sea Project* are from this page of the book.

20. "Safe-haven" is a term that Rafael Montanez Ortiz used in conversation with me in 1982 to describe why he turned to art as a refuge from the racism he suffered as a Puerto-Rican American. See my "Rafael Montanez Ortiz," in *Rafael Montanez Ortiz: Years of the Warrior 1960 — Years of the Psyche 1988* (New York: El Museo Del Barrio, 1988).

21. Donald Judd, "Specific Objects," *Arts Yearbook* 8 (1965), reprinted in *Donald Judd: Complete Writings 1959–1975* (New York and Halifax: The Press of the Nova Scotia College of Art and Design and New York University Press, 1975), p. 181.

22. Sheldon Nodelman, *Marden, Novros, Rothko: Painting in the Age of Actuality* (Seattle and London: Institute for the Arts, Rice University, distributed by University of Washington Press, 1978), pp. 84–85.

23. See for example, Arthur Danto, *The Death of Art*, ed. Berel Lang (New York: Haven, 1984).

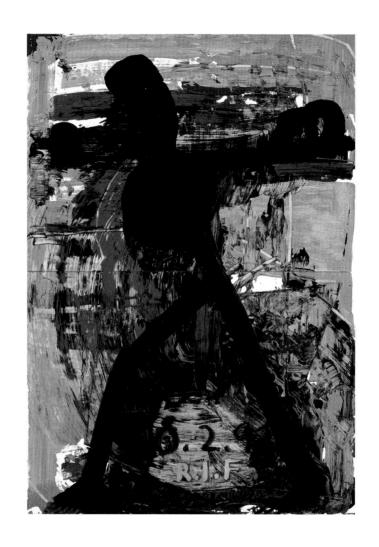

10/2/91: RIF
1991
Acrylic, oil, and collage
Collection of the artist

Influences on the Art of Pinchas Cohen Gan

Like most postmodern artists—and in contrast to most modernists—Israeli artist Pinchas Cohen Gan has not been constrained by matters of art media or "signature" styles. Rather, welcoming apparent contradictions, he conflates many different modes of working. Neither has Cohen Gan been limited by any one twentieth-century philosophical or scientific movement. Instead, he uses the tools of linguistic theory, mathematical formulas, cybernetic systems, and information theory as a fertile bed of inspiration. More important to his work than allegiance to any one art style or intellectual movement has been his continuing attempt to fuse humanity, art, and science, or, to use his phrasing: Figure/Form/Formula.

Cohen Gan's earliest work was autobiographical and in an expressionist vein, exemplified by vigorous lines, cursory shading, and asymmetrical composition. *Bandaged Figure* (1968) relates directly to his injury by a terrorist's bomb in Jerusalem. It was made during his time of study at the Bezalel Academy of Art in Jerusalem, which then comprised a good many teachers working in the German expressionist tradition.

In 1970 Cohen Gan left Israel to continue his studies at the Central School of Art in London. Impressed by the manipulation of popular imagery by Eduardo Paolozzi and Richard Hamilton, the experimentation with figural representation by David Hockney, and Barry Flannagan's exploration of unorthodox materials and techniques, he began

Peter Selz

References

bibliography provided by
Pinchas Cohen Gan

1996

Encyclopedias and Dictionaries

Anthony Chandor, James Graham, and Robin
Williamson, *A Dictionary of Computers*, 1970

Kurk Gieck, *Engineering Formulas*, 1979

Carol Horn Greenstein, *Dictionary of Logical Terms and
Symbols*, 1978

H. Kober, *Dictionary of Conformal Representations*, 1957

Walter Shepherd, *Shepherd's Glossary of Graphic Signs and
Symbols*, 1971

George Spencer-Brown, *Laws of Form*, 1977

The Universal Encyclopedia of Mathematics, 1964

Van Nostrand's Scientific Encyclopedia, 1976

to move away from expressionism. His work from this period was highly innovative. In *Figure and Order* (1971) he used the techniques of solarized photography to camouflage the male figure, neutralizing the face with wide bands. In *Still Life with Model* (1973) he placed a female model in a stable surrounded by cows, a bizarre image that made reference to his first exhibition of twenty-two etchings, which he held in a cowshed in a kibbutz after his return to Israel in 1972. This photo-etching, based on a magazine illustration, would have been savored by the surrealists.

In 1972 Cohen Gan began a series that he called *Activities*. Traveling to far reaches of the globe, to Alaska and South Africa, he fused geographical, environmental, and political strategies with his personal psychological concerns. He documented his journeys with photo-etchings, but he also reduced gigantic projects, such as his trip to the northernmost point on the American continent in Alaska, to minimalist drawings, geometric designs, and mathematical formulas.

In the mid-seventies, while living in New York and studying at Columbia University, Cohen Gan began to work in a minimalist/conceptual vein. In a series of seventeen works called *Definitions 1–17* (1973), he used the seventeen cardinal definitions of mathematics, illustrated by color squares done with a felt pen on cloth napkins, and arrived at largely through visual intuition.

But by 1976 the intuitive aspect of making art and the desire to come to grips with the human image reasserted themselves. Soon, "like many artists who began their careers in the early 1970s, he attempted to break through the confines of minimal and conceptual aesthetics that dominated the art world."[1] As the artist wrote, "In the later seventies, dealing with the theme of man is only natural, not only because the post-minimalists have carried abstract art to its very limit, but also because this subject has been treated for nearly two thousand years."[2]

Thus, Cohen Gan found his way back or forward toward figuration, incorporating the human image into his Figure/Form/Formula concept, which relates man, art, and science.

Although Cohen Gan cannot be neatly characterized as a proponent of any one art or philosophical movement, he has always found inspiration in the intellectual movements of his time. In fact, he observed in 1989, "The postmodern artist works like a philosopher."[3] In embracing,

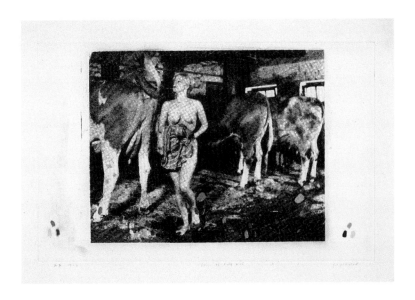

abandoning, and returning to figuration, Cohen Gan anticipated the path
that the dispute between abstraction and figuration was to take in the
late twentieth century. As Jean Clair, the director of the Venice Biennale
in 1995, commented in the exhibition catalog: "Perhaps no other century
has tried so intensely to restore—against encroaching deserts—human
presence."[4]

In 1949, at about the time that seven-year-old Pinchas Cohen Gan was
emigrating to Israel from his native Morocco, sculptors in France like
Germaine Richier and César were creating fractured figures of tormented
appearance as survivors as well as victims. Their hybrid figures related to
the metamorphosis and ambiguity that were central to the existentialists'
speculations about human existence. Giacometti pared his solitary
walking men and standing women down to the barest essence of being,
relating them closely to Sartre's concept of "Nothingness." Jean Fautrier's
Hostages can be seen as tragic ideograms, while Dubuffet's distorted
figures, like the theatre of Artaud and Beckett, take part in a ritual sort
of bizarre comedy to deal adequately with the tragedy of human
existence.

While European artists created works communicating their concern for
an anguished and struggling humanity, facing "horror and absurdity
while still retaining their human dignity to preserve their individuality,"[5]
American artists, living and working in a country far removed from the

Still Life with Model
1973
Photo-etching
Museum of Israeli Art, Ramat Gan

Art and Aesthetics

Götz Adriani, Winfried Konnertz, and Karin Thomas, *Joseph Beuys,* 1973

Leon Battista Alberti, *On Painting,* 1956

Lawrence Alloway, *Topics in American Art since 1945,* 1975

Jack Burnham, *The Structure of Art,* 1971

Suzi Gablik, *Has Modernism Failed?,* 1984

Nelson Goodman, *Languages of Art: An Approach to a Theory of Symbols,* 1968

Yves Klein, *Le Depassement de la Problematique de L'Art,* 1959

Joseph Masheck, *Marcel Duchamp in Perspective,* 1975

Abraham A. Moles, *Information Theory and Esthetic Perception,* 1968

Robert Pincus-Witten, *Postminimalism,* 1977

Jasia Reichardt, *Cybernetics, Art, and Ideas,* 1971

Ad Reinhardt, *Art As Art: The Selected Writings of Ad Reinhardt,* 1975

Maurice Tuchman, *New York School the First Generation: Paintings of the 1940s and 1950s,* 1965

Kirk Varnedoe, *A Fine Disregard: What Makes Modern Art Modern,* 1990

Lionello Venturi, *History of Art Criticism,* 1936

horrors of war, began to follow individual impulses in their subjective gestures of liberation and exploration. By the 1960s, American artists had embraced a new concept called "conceptual art."

Conceptual art postulated that language and ideas, rather than the material object, were the proper subject of art. Conceptual art can be seen as a consistent and ultimate step in a continuous series of renunciations regarding the purpose of art, moving art from narrative and sensory artifacts, to pure flat surfaces impregnated with color, and, finally, to the full negation of the art object. It is worth noting that conceptual art originated and flourished in America, with its tradition of Puritanism, which denied aesthetic enjoyment on principle. The ultimate statement of the theory of conceptual art was made by Joseph Kosuth in 1968, when he asserted that "art's viability is not connected to the presentation of visual kinds of experience."[6]

Israeli artists were attracted by the conceptual art movement. They directed their antennae toward the New York art world and frequently visited and exhibited there. Many Israeli artists, including Joshua Neustein, Schlomo Korn, Benni Efrat, Michael Druks, Avital Geva, Nahum Tevet, and Mati Krüberg, worked in the minimalist and conceptual modes, as Menasche Kaddisman did in 1972, when he crossed out names and addresses in telephone directories from all over the world, transforming images of these totally anonymous books into personal drawings of obliteration.

The restoration of recognizable imagery in art was advanced by trends during the pluralist 1960s, including pop art and photo-realism (which achieved the status of a movement in America), or—more important for Cohen Gan—the so-called trans-avantgarde in Italy and various manifestations of refiguration in Germany and elsewhere. With the ever-accelerating impact of the mass media, the individual himself became Mass-Man, as had been predicted by Franz Kafka or by Robert Musil in his epoch-making novel *The Man without Qualities* early in the century. Now artists including Jonathan Borofsky, Sandro Chia, Enzo Cuchi, Keith Haring, and A. R. Penck painted pictures of anonymous human beings, trivialized persons. Mere functionaries, the subjects of this art depended on external forces with which they interacted as mere automatons.

In the United States, figuration had been largely marginalized by the mainstream of abstract paintings and its claim for universality. But, after painting some of the most luminous abstract paintings in the 1950s, Philip Guston felt that there was more to painting than that: "When the 1960s came along I was feeling split, schizophrenic. The war, what was happening in America, the brutality of the world. What kind of man am I, sitting at home, reading magazines, going into frustrated fury about everything—and then going into my studio to *adjust a red to a blue*. I thought there must be some way I could do something about it."[7]

Mingling the grotesque with the commonplace, Guston found his way to a new figuration and a personal rich iconography, dealing with his view of the world and with living and dying. But his work, much of it with political overtones, was severely criticized, and remained on the periphery for some time, as were the political statements by artists such as Leon Golub and Edward Kienholz.

When Cohen Gan returned to the figure in a series of 1976 paintings done on tablecloths, he made small figures moving like puppets, be it toward a fire or to a series of color squares. It seems to make little difference whether his figures moved toward a natural phenomenon like fire or geometric forms of his own creation. The figure in *Walking Man* (1976), with the suggestion of a crown on his head, appears to have emerged from Plato's cave to hit a square of color with his stick. Cohen Gan's oils from this period can be seen as mediations between figuration and abstraction. Like the great, androgynous, universal figures in Oskar Schlemmer's paintings, sculptures, and ballets, Cohen Gan's figures are stripped of all accidental and nonessential qualities. They are Everyman, but now they are also No-Man—nameless beings.

Cohen Gan's human forms became even smaller in *Figures 1-59* (1977). These little people, alone or in couples, propelled by useless energy, run, skate, lie, bend. They are so tiny that they appear to be like diagrammatic signs. Cut from large colored-paper rectangles, they appear like irrational humans located in a rational system.

Later in 1977 Cohen Gan constructed *Rampman against a Portable Field*, an installation that consisted of seven large, monochrome, plywood panels. He then photographed that artificial wall with and without a man (small) walking alongside it, evoking a sense of almost boundless isolation. During that same year, he cut figures out of cardboard and pasted them in an upright or prostrate position on top of sheets of

Philosophy

Fritjof Capra, *The Tao of Physics: An Exploration of the Parallels Between Modern Physics and Eastern Mysticism*, 1975

Arthur C. Danto, *What Philosophy Is: A Guide to the Elements*, 1968

Paul K. Feyerabend, *Against Method: An Outline of an Anarchistic Theory of Knowledge*, 1975

Martin Heidegger, *What is a Thing?*, 1967

Martin Heidegger, *Discourse on Thinking*, 1969

Graham Nerlich, *The Shape of Space*, 1976

Hans Reichenbach, *The Philosophy of Space and Time*, 1958

Bertrand Russell, *Unpopular Essays*, 1950

Bertrand Russell, *The Problems of Philosophy*, 1978

Paul Tibbetts, *Perception, Selected Readings in Science and Phenomenology*, 1969

Maurice Trask, *The Story of Cybernetics*, 1971

Hermann Weyl, *Philosophy of Mathematics and Natural Science*, 1963

Michael Whiteman, *Philosophy of Space and Time and the Inner Constitution of Nature: A Phenomenal Study*, 1967

Ludwig Wittgenstein, *Philosophical Investigations*, 1958

Lewis Yablonsky, *Robopaths*, 1972

newspaper that he had covered with high-gloss synthetic paint. Sharply torn and scored strips of newsprint give a vibrant texture to the lower register. These collages are called *East West Erosion Figure* (1977), a title that refers to the dichotomy between the more sensate East and the more intellectual West.

Works of this kind were exhibited at the Rina Gallery and the Max Protech Gallery in New York. They were to be included with paintings by artists such as Nicholas Africano, Neill Jenny, Robert Moskowitz, and Susan Rothenberg in the pivotal "New Image Painting" exhibition in 1979 at the Whitney Museum of American Art, but the Whitney was not able to show the work of an Israeli artist.

In *Blue State* (1980), done in strong color and with a vigorous brush stroke, Cohen Gan seems completely engaged in the act of painting. But in the same year he made a large assemblage in which he placed a male figure, armed with a rifle, on top of a painted shallow box, attacking a big square monochrome canvas. He named it *Propositional Painting*, explaining that a "painted proposition…is a concrete conclusion of an artistic object that relates in form and content to some concept in the history of art."[8] Some have speculated that the concept referred to in this work is the assassination of painting—a speculation that Cohen Gan has never confirmed.

Political events also exerted an influence on Cohen Gan's work. In 1982 he responded to the Likud's ruthless invasion of Lebanon with a powerful series of dark pen and brush drawings depicting the horror of aerial bombardment. In *Drawing of the Lebanon War* (1982), he gave his own personal rendition of the airplane dropping bombs, which has almost become a visual symbol of the twentieth century.

Although he had distanced himself from conceptual art, Cohen Gan continued to be eminently involved with ideas and their translation into visual symbols. In *Relational Art and Absolute Art* (1982), he postulated a cybernetic system of flow from speech to vision and form and on to theory of form. Knowledgeable in information theory, he proposed a visual context in which different forms of perception and thought can be

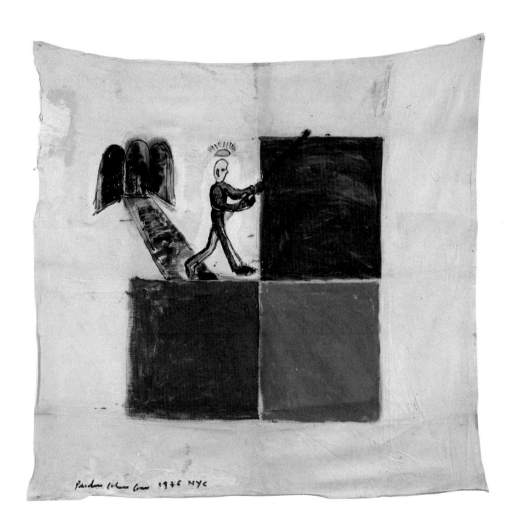

Walking Man
1976
Oil on tablecloth
Collection of the artist

Language, Semiology, and Grammar

Roland Barthes, *Elements of Semiology*, 1968

Roberto Bonola, *Non-Euclidean Geometry*, 1955

Yuen Ren Chao, *Language and Symbolic Systems*, 1968

Noam Chomsky, *Language and Mind*, 1968

Noam Chomsky, *Language and Problems of Knowledge*, 1988

P. C. W. Davies, *Space and Time in the Modern Universe*, 1977

Michel Foucault, *The Order of Things: An Archeology of the Human Sciences*, 1970

Pierre Guiraud, *Semiology*, 1975

Terence Hawkes, *Structuralism and Semiotics*, 1977

Frederic Jameson, *The Prison-House of Language: A Critical Account of Structuralism and Russian Formalism*, 1972

Charles Kay Ogden and I. A. Richards, *The Meaning of Meaning: A Study of the Influence of Language upon Thought and of The Science of Symbolism*, 1923

Edward Sapir, *Language: An Introduction to the Study of Speech*, 1949

Ludwig Wittgenstein, *Zettel*, 1967

Ludwig Wittgenstein, *On Certainty*, 1969

related. In the early 1980s, he developed a system he called "atomic art," in which minute dots—much smaller than Roy Lichtenstein's benday dots—create a picture that appeared to be a composition of scanned electric pulses. Among an impressive number of theoretical books is his *Atomic Art*, issued in 1988. He also made a series of gouaches, such as *Art* (1982), referring to this book.

At this time expressionism—ameliorated or balanced by mathematical formulation—returns to his work in *Confrontation of Painting and Formula* (1982). These works accurately describe the contraposition he uses between the colorful images of human figures embroiled in a chaotic maelstrom in the upper register and the non-Euclidean geometric designs below. Cohen Gan maintains that Euclidean geometry and logical positivism are closely related to formalist art, which became increasingly insufficient for the mysterious aspects of the creative act. In his work, non-Euclidean geometry, going back to N. I. Lobachevsky (1793–1856) helped to motivate Cohen Gan's quest for artistic innovation. In this series, the artist again juxtaposes artistic self-expression (figure) with scientific diagrams (formula) to create a dialectic synthesis of the pictorial and the conceptual elements in his art.

He used a similar apposition in *Language Trees* (1985). In the upper section we see compositions done in strong expressionist color, painted with acrylic and felt pen. Here we can decipher Hebrew letters, human figures, animals, abstract elements. In *Somebody Must Have Noticed* (1995) there is a red Star of David and green and red heads, disembodied and thus separated from human reality. In the lower section Cohen Gan again turns to linguistic texts, appropriated from books on the structure of English grammar. Again he searches for a fusion of visual and linguistic elements in human endeavor.

Cohen Gan's *Prodigal Son* suite (1989) combines painting and sculpture. Cutting out plywood stick figures from actual sticks of wood, he placed them on top of monochrome canvases, mostly dark in color. The attenuated figures are stiff generic wooden puppets that avoid individualization. Recalling the nonindividuals predicted in Norbert Wiener's *Cybernetics,* they are objects of external forces, cogs in a mechanized and centralized society, rather than full-fledged human beings. As prodigal-son images, they refer to the peripheral and marginalized position of the artist in the modern world, and they also have an autobiographical meaning. They stand for Pinchas Cohen Gan

himself—not only the artist as alien, but also the Sephardic African Jewish immigrant to Ashkenazi Israel, the outsider, the prodigal, seeking to come home.

Cohen Gan's most recent work moves beyond personal or theoretical concerns to interact with the political system, exploring a new imagery to confront the perplexing and often desperate plight of the place of art at the fin-de-siècle. During the 1991 war in the Persian Gulf, euphemistically designated Operation Desert Storm by President George Bush, Cohen Gan made a series of acrylics painted in strong reds, blues, and blacks. The subject of this series is the infamous scud missiles, which in Cohen Gan's depiction consist of swirling black circles, human heads of phantom figures, a mortar, a golden Star of David, and, most tellingly, the words "Aouto-da'fe" (sic), reminding the viewer of the old ritual of burning human beings. These paintings, like those of the Lebanon War, are powerful condemnations of war.

In 1996 the artist produced another eloquent series of politically engaged paintings, *The Foundation of the State of Israel from the Viewpoint of the Children*. In most of these paintings, a human figure—standing, running, walking, bending, or sitting—takes up the major part of the picture space, onto which Cohen Gan collages a photograph. *Theodor Herzl* represents the founder of modern Zionism in his well-known portrait photograph with a disembodied head below his picture. *Dr. Korczak* shows the subject with a crowd of Jewish orphans. Dr. Janusz Korczak was a Polish Jewish pediatrician who devoted his life to taking care of the orphaned children in Warsaw. After two trips to Eretz Israel (Palestine at the time) in 1934 and in 1935, he became convinced that the future of the Jewish people was in the land of the *kibbutzim* and *moshavim*, the socialist agricultural settlements that he had seen and admired. But when the war came, Korczak was caught in the Warsaw ghetto. Because he would not leave the 200 orphans under his charge, he refused opportunities to escape and was finally deported with the children to the camp in Treblinka. The photograph *Beating* shows a Nazi soldier hitting a Jew on the back while a crowd of people stand by watching in the background. In *Deportation*, a figure is bent over a photo of a multitude of people who have been rounded up in the Jewish ghetto before deportation to a concentration camp and cremation. In the *Declaration of the State of Israel by Ben-Gurion,* the figure is seated on the edge of the photograph. In *School,* the figure walks with a flag in hand above a photograph of children and teacher.

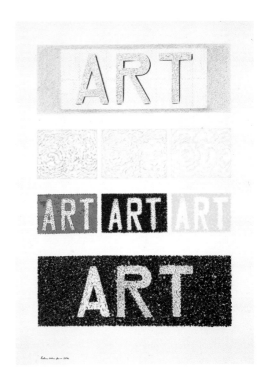

Art

1982
Gouache and pencil
Collection of the artist

Mathematics, Geometry, Morphology, and Topology

Ludwig Eckhart, *Four-Dimensional Space,* 1968

Harry Lindgren, *Geometric Dissections,* 1964

Kenneth S. Miller, *A Short Course in Vector Analysis,* 1962

Tim Poston and Ian Stewart, *Catastrophe Theory and Its Applications,* 1978

Alexander Edward Richard Woodcock and Monte Davis, *Catastrophe Theory,* 1978

Books of Special Interest

Albert Einstein, *Relativity,* 1961

Ervin Laszlo, *Introduction to Systems Philosophy: Toward a New Paradigm of Contemporary Thought,* 1972

Dietrich Schroeer, *Physics and Its Fifth Dimension: Society,* 1972

Ludwig Wittgenstein, *Tracatus Logico-Philosophicus,* 1961

Ludwig Wittgenstein, *The Blue and Brown Books,* 1965

Ludwig Wittgenstein, *Remarks on the Foundations of Mathematics,* 1975

In a 1996 interview Nick Pappas, an associate professor of philosophy at City College of New York, responded to a question about how artists use philosophy. His comments offer insight into the way in which artists borrow, absorb, and sometimes warp information: "I had a photographer friend tell me that what an artist does with philosophy is misunderstand it until it's interesting. That's one thing you can do. You can treat something as raw material, do whatever you want with it, and not worry about what it's actually saying. Perfectly acceptable. I mean, there's no one thing you can do with a pear, why should there be one thing to do with a book of philosophy?" [9]

That Cohen Gan uses philosophy and science as an undiluted source of information to inspire his art is one way of interpreting his *oeuvre.* "I believe in art as an enigma, not as a system," he has said. "Scientific thinking can provide large structures of reference which are worth using." [10] For Pinchas Cohen Gan, creativity cannot be defined or analyzed by scientific or philosophical standards. Instead, creativity confronts nature, science, and philosophy, thus allowing the artist to explore humanistic, logical, and rational values.

Notes

1. Richard Marshall, "Jonathan Borofsky's Installations: All is One," in *Jonathan Borofsky*, by Mark Rosenthal and Richard Marshall (Philadelphia: Philadelphia Museum of Art, 1984), p. 88.

2. Pinchas Cohen Gan, in *Proposition Painting,* exhibition catalog (Kingston, R.I.: University of Rhode Island Fine Arts Center, 1979), n.p.

3. Cohen Gan, "Post-Modernism on the Way to Deconstruction: Summation and Criticism" (Mimeographed leaflet; Jerusalem: Bezalel Academy of Art, 1989), n.p.

4. Jean Clair, "Impossible Anatomy 1895–1995," in *Identity and Alterity: Figures of the Body 1895–1995,* exhibition catalog for *La Biennale di Venezia* (Venice: Marilio Editori, 1995), p. xxxi.

5. Simone de Beauvoir, *Force and Circumstance* (Paris, 1960; New York: G. P. Putnam and Sons, 1963), p. 39.

6. Joseph Kosuth, "After Philosophy." Originally published in *Studio International* 178, no. 915 (October 1969): 98. Reprinted in Kristine Stiles and Peter Selz, *Theories and Documents of Contemporary Art* (Berkeley: University of California Press, 1996), p. 846.

7. Quoted by Musa Meyer in *Night Studio* (New York: Alfred A. Knopf, 1988), p. 171.

8. Cohen Gan, "Scheme Illustrating an Operational Law of Relative Art," in *Pinchas Cohen Gan 1983*, by Mordechai Omer (Haifa: Haifa Museum of Art, 1983), p. 76.

9. Katy Martin, "An Interview with Nick Pappas," *Bomb* 56 (Summer 1996): 69.

10. Quoted by Sara Breitberg in *Pinchas Cohen Gan*, exhibition catalog (Tel Aviv Museum of Art, 1978), p. 42.

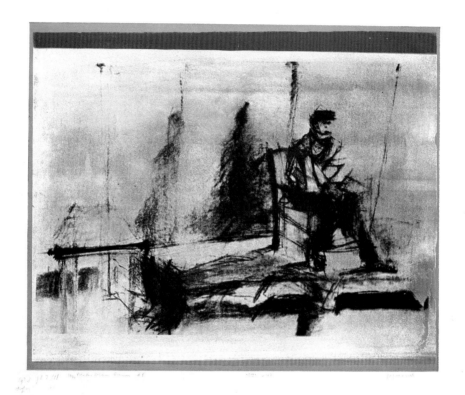

Bandaged Figure
1968
Photo-etching and aquatint
Museum of Israeli Art, Ramat Gan

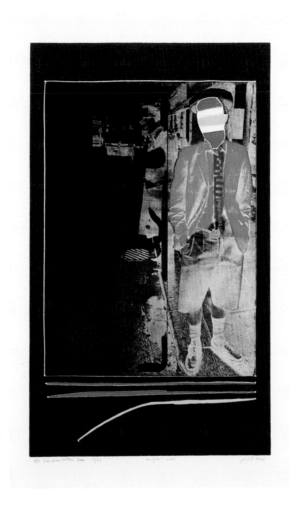

Figure and Order
　1971
　Photo-etching and embossment
　Museum of Israeli Art, Ramat Gan

Exhibition of Etchings in the Cowshed of Kibbutz Nirim

1–12 February 1972

The Activity

Twenty-two etchings were displayed in a single row over the cows' mangers. The exhibition lasted for twelve days, twenty-four hours a day. The event took place on the regular route of the members of Kibbutz Nirim. This was Cohen Gan's first one-man show. The specific conditions in which it was held were defined as a reaction against establishment places of exhibition.

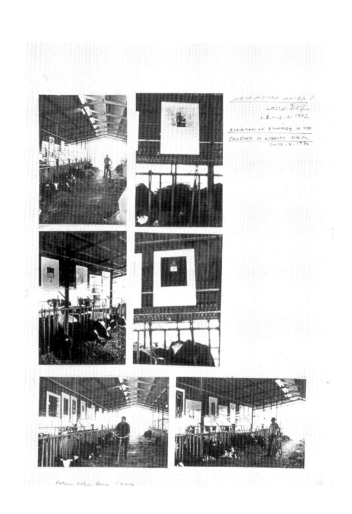

Exhibition of Etchings in the Cowshed of Kibbutz Nirim
1–12 February 1972
Photographs and text
Collection of the artist

Dead Sea Project

Autumn 1972–Spring 1973

Background

The launching of the first satellite upset the relationship between man and his natural environment, creating a condition of anti-environment. The mass emigration from various countries to Israel can now be defined as a transition from a natural environment to a new environment that seeks to form the patterns of a natural environment.

Definition of the Activity

The creation of living conditions in a relatively dead area

Components of the Activity

The boat: A boat, 3 meters long and 1.20 meters wide, is built at Acre from eucalyptus wood (spring 1973). The boat is to be launched on the Dead Sea to mark the route of life (not carried out).

Transplantation: Polythene "sleeves" were connected to the spring at Ein Rouer, south of Ein Feshha, and floated on the Dead Sea. Fish that were isolated in the "sleeves" lived within an environment in which life is not possible (May 1973).

Summary

Fish in sweet water are transferred to the Dead Sea. Its saltiness increases the greater the distance from the source of the sweet water. As life and salt exist in inverse proportions, the possibility of the existence of life decreases the farther we move from the source.

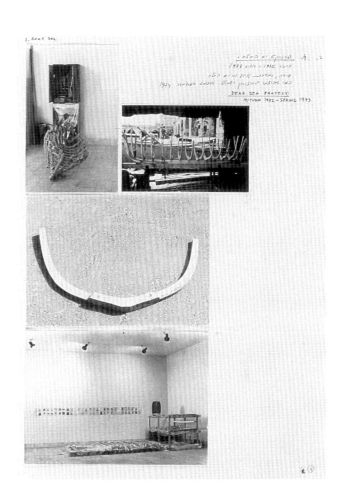

Dead Sea Project
Autumn 1972–Spring 1973
Photographs and text
Collection of the artist

Place

April–May 1973

Shown at the Yodfat Gallery, Tel-Aviv

Definition of the Activity
A place as a physical occasion

Components of the Activity
Hewing of the upright figure of a man in the gallery wall

Boring of four holes in the gallery wall and insertion of four iron pegs that allow visitors to climb, hang, etc., within the figure of the hewn man

Screening of a film (2 minutes long, 16 mm) showing the 43rd presentation of degrees of Bachelor of Arts of the Hebrew University, February 1973.

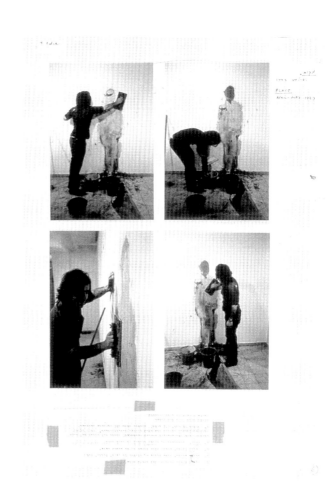

Place
April–May 1973
Photographs and text
Collection of the artist

Journey to Alaska

June–August 1973

Components of the Activity

25 June–21 August: Conover, Wisconsin, U.S.A.
Preparation of the action, planning, definition of
a set of images and meanings connected with a
specific territory (Alaska). Expression of the
preparations in writing and drawing.

22–30 August: Flight and stay in Alaska.
Application of the set of images and meanings in
photographs and collected objects.

Conclusion

The end of geography and yourself.

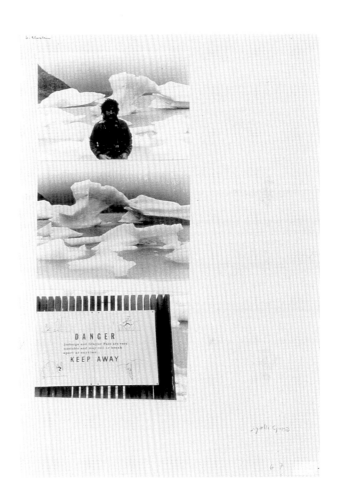

Journey to Alaska
 June–August 1973
 Photographs and text
 Collection of the artist

Alaska Project I
1973
Photo-etching and pastel photo-lithograph
Museum of Israeli Art, Ramat Gan

Touching the Border

7 January 1974

Components of the Activity

Four Israeli citizens travel toward the four borders during the 1973 Yom Kippur War..

When they read the borders, they mark the points where they are stopped by the army.

At these points a lead bar measuring 0.4 x 100 x 4 cm is buried, which is stamped with demographic—partly intelligence— information (the data being taken from *Time* magazine, 15 October 1973).

Simultaneously four letters are sent to the artists' associations of Lebanon, Syria, Egypt, and Jordan with the request that they carry out the same action on their borders.

Media

Travel, photography, documentation

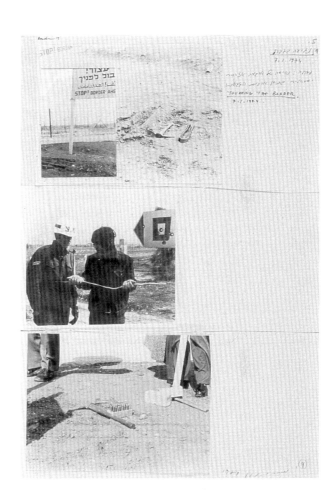

Touching the Border
7 January 1974
Photographs and text
Collection of the artist

Action in the Jericho Refugee Camp

10 February 1974

Place

The refugee camp in the northeastern sector of
the Jericho, near Hisham's Palace

Components of the Activity

A talk given to two refugees and my companions
on Israel's conditions in twenty-five years' time,
in the year 2000;

Declaration: "A refugee is a man who cannot
return to his birthplace."

Construction of a temporary shelter

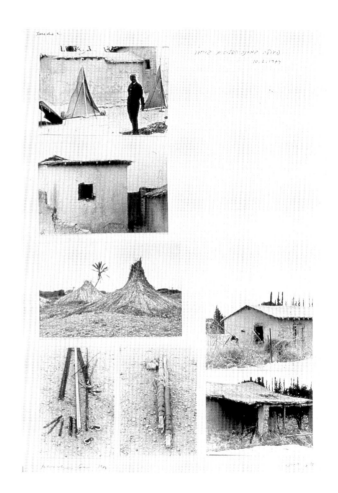

Action in the Jerico Refugee Camp
10 February 1974
Photographs and text
Collection of the artist

Carrots

15 March 1974

Place
A carrot field at Kibbutz Nirim

Components of the Activity
Follow up and observation of the carrots' growth taken about 60 cm under the surface of the soil.

Connections
"This work is connected with the Jericho work in that here I demonstrate a process or system which is valid in a given area, or the earth in its other function. Instead of areas of dispute, areas of life, in which there is a carrot reality. In a sense I would connect this work with a mythology of the earth."

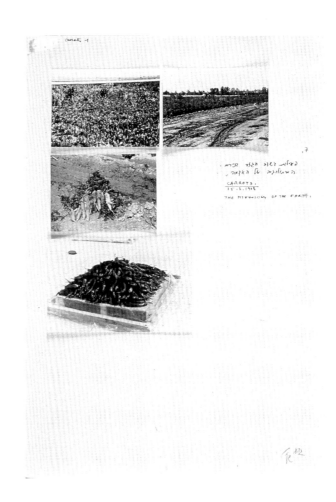

Carrots
15 March 1974
Photographs and text
Collection of the artist

Carrots, Action in a Carrot Field at Kibbutz Nirim
1974
Photo-etching and pastel photo-lithograph
Museum of Israeli Art, Ramat Gan

South Africa, the Cape of Good Hope

3 March–18 April 1974

Components of the Activity

Transportation of two gallons of Dead Sea water to Cape Point at the end of the peninsula called the Cape of Good Hope

Pouring of the Dead Sea water into the water at the point where the waters of the two oceans— the Indian and the Atlantic—meet

Result

Through this action the amount of salt in the oceans rose by an indeterminable percentage.

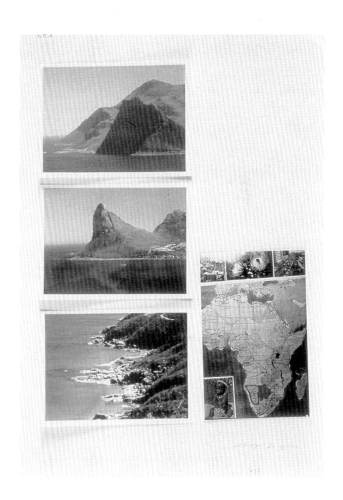

South Africa, the Cape of Good Hope
3 March–18 April 1974
Photographs and text
Collection of the artist

Drilling

26 April 1974

Place

19 Rehov Hamadregot, Jerusalem,
at the artist's studio and home

The Activity

The introduction of sweet water with the
intention of changing a permanent condition of
water circulation in the Dead Sea through the
water cycle in nature

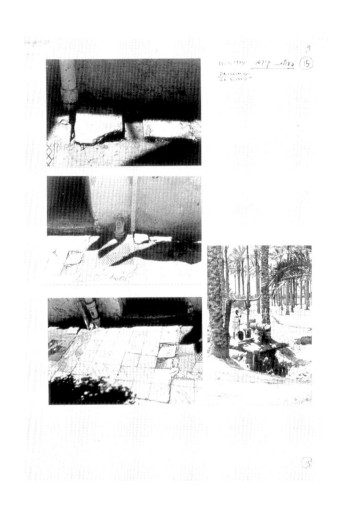

Drilling
26 April 1974
Photographs and text
Collection of the artist

Biography/Range of Adaptation

23 June 1974

Subject of activity
My environment and the objects in it

Components of the Activity
Measuring of the distances between the objects in my room

Representations of these objects as outlined in lead piping having a diameter of 10 mm with moveable joints

Transferring the objects to a large area of the desert 10 km in size

Placing the objects in identical proportion to their place in my environment

Referring to significant places in my life (Morocco, Kiryat Bialik, Jerusalem)

Summary
Objects pertaining to my everyday environment are represented by outlines created in lead piping having a diameter of 10mm with movable joints. The pipe outlines are placed in the desert.

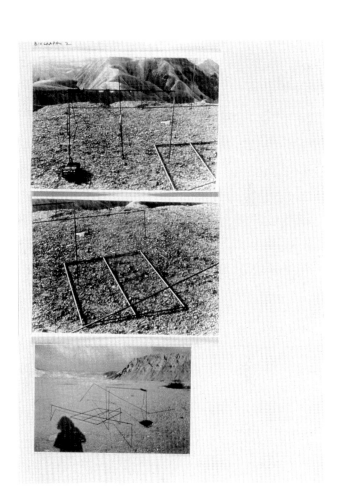

Biography/Range of Adaptation
23 June 1974
Photographs and text
Collection of the artist

On Drawing, a Manifesto
1973–74
Conte crayon and graphite
Collection of the artist

Choice of Location

1973

Silk-screen on sewn cloth containing a reproduction

Museum of Israeli Art, Ramat Gan

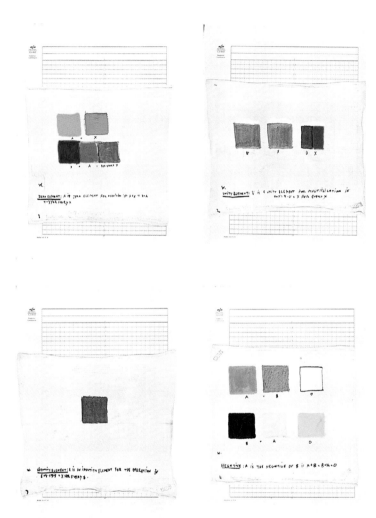

Definitions 1–17:
Zero Element, Unity Element, Identity Element, Negative
> 1975
> Felt pen, oil, and napkin on photo screenprint
> Tel Aviv Museum of Art
> Gift of the artist

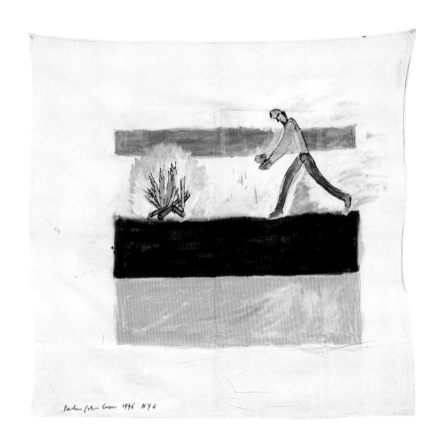

Man with Fire
 1976
 Oil on tablecloth
 Collection of the artist

Confrontations of Painting and Formula
 1982
 Acrylic, pencil, and collage
 Tel Aviv Museum of Art

Confrontations of Painting and Formula
 1982
 Acrylic, pencil, and collage
 Tel Aviv Museum of Art

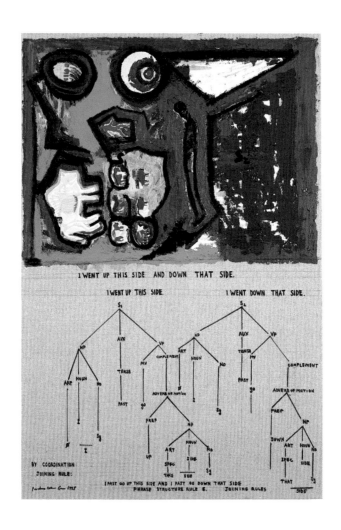

I Went Up This Side and Down That Side
1995
Acrylic, felt pen, and paper on canvas
Collection of the artist

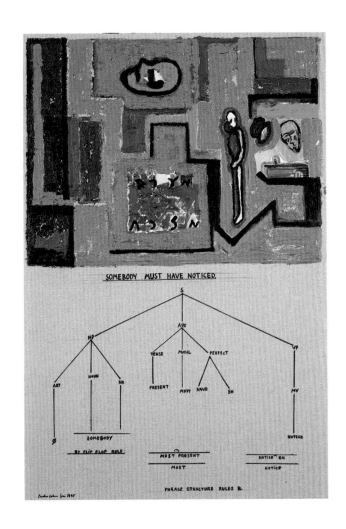

Somebody Must Have Noticed

 1995

 Acrylic, felt pen, and paper on canvas

 Collection of the artist

Figure, Form, Formula, begins 1976

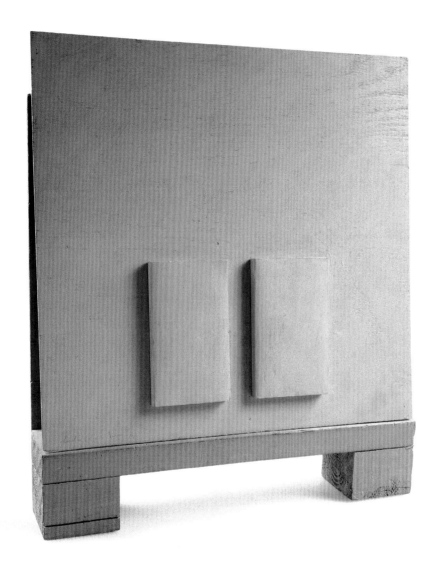

Shelf

1976
Oil on wood
The Israel Museum Collection, Jerusalem
Purchased through the gift of the Florence Louchein Stol Foundation

Figure, Form, Formula: Jerusalem Post
1977
Cut and torn layers of newsprint and ink
Collection of the artist

Electronic Picture
 1987
 Graphite
 Collection of the artist

Alphabetique—l'objet, c'est l'oeil
1995
Acrylic, cardboard, and paper on canvas
Collection of the artist

Language of Art
1988
Acrylic, cardboard, and wood on canvas
Collection of the artist

Prodigal Son C
1989
Acrylic and wood on canvas
Collection of the artist

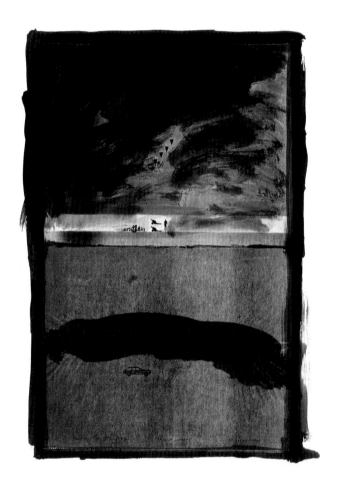

Drawing of the Lebanon War
1982
Pen and brush with ink, adhesive letters,
and collage
Tel Aviv Museum of Art
Gift of the artist

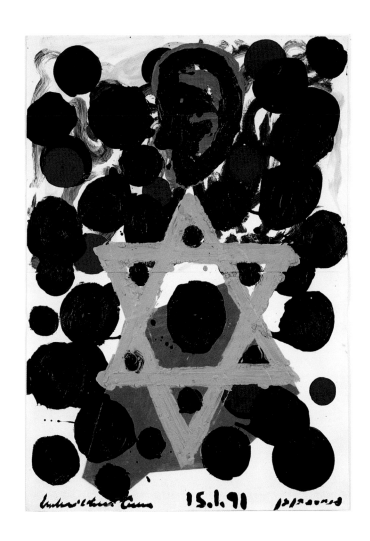

15/1/91

1991

Acrylic, oil, and collage

Collection of the artist

Logic Furniture, begins 1995

Subtraction
1995
Acrylic, ink, and canvas on cardboard
Collection of the artist

V^1 Universe
 1996
 Oil crayon and acrylic
 Collection of the artist

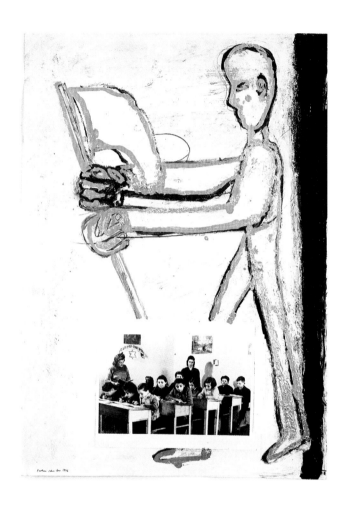

**The Foundation of the State of Israel from the
Viewpoint of the Children**
School
 1996
 Oil, crayon, acrylic and photographs
 Collection of the artist

Dimensions are given in inchs, height precedes width, precedes depth.
Unless otherwise noted, all works are on paper and all multiples are the
artist's proof. When works in series are ongoing they are indicated by
beginning dates only.

Jerusalem, 1968–70

Bandaged Figure
1968
Photo-etching and aquatint
22 x 29¾
Museum of Israeli Art, Ramat Gan

London, 1970–71

Family Portrait
1970–71
Photo-etching and embossment
29⅞ x 22¹/₁₆
Collection of the artist

Realism
1971
23½ x 31⅛
Etching and silk-screen
Museum of Israeli Art, Ramat Gan

To Tara
1971
Etching and colored threads
31¹/₁₆ x 23¹/₁₈
Collection of the artist

Figure and Order
1971
Photo-etching and embossment
30¾ x 23¼
Museum of Israeli Art, Ramat Gan

Activities, 1972–76

**Exhibition of Etchings in the Cowshed of
Kibbutz Nirim**
1–12 February 1972
Photographs and text
Collection of the artist

Still Life with Model
1973
Photo-etching
19½ x 25¾
Museum of Israeli Art, Ramat Gan

Dead Sea Project
Autumn 1972–Spring 1973
Photographs and text
Collection of the artist

Dead Sea Revivification Project
1972–73
Charcoal, inks, chalk, and graphite
One from a series of ten, 27½ x 39¼
Tel Aviv Museum of Art
Gift of the artist

Place
April–May 1973
Photographs and text
Collection of the artist

Journey to Alaska
June–August 1973
Photographs and text
Collection of the artist

Alaska Project
1973
Pencil, oil pastel, and charcoal
One from a series of three, 21½ x 23
Tel Aviv Museum of Art

Alaska Project I
1973
Photo-etching and pastel photo-lithograph
29¾ x 22$\frac{1}{16}$
Museum of Israeli Art, Ramat Gan

A Record: Alaska Project
1973
Sound wave printing on record
13⅜ x 13⅜
Museum of Israeli Art, Ramat Gan

Touching the Border
7 January 1974
Photographs and text
Collection of the artist

Zero Degree of Printing
1974
Photo-etching and aquatint
29¾ x 22$\frac{1}{16}$
Museum of Israeli Art, Ramat Gan

I am Too Upset for Art
1974
Photo-etching and aquatint
29¾ x 22$\frac{1}{16}$
Museum of Israeli Art, Ramat Gan

Border Contact
1974
Photo-etching
29¾ x 22$\frac{1}{16}$
Museum of Israeli Art, Ramat Gan

Action in the Jerico Refugee Camp
10 February 1974
Photographs and text
Collection of the artist

Carrots
15 March 1974
Photographs and text
Collection of the artist

Carrots, Action in a Carrot Field at Kibbutz Nirim
1974
Photo-etching and pastel photo-lithograph
29¾ x 22$\frac{1}{16}$
Museum of Israeli Art, Ramat Gan

South Africa, the Cape of Good Hope
3 March–18 April 1974
Photographs and text
Collection of the artist

Africa Diary: Preparation for a Trip to the Cape of Good Hope
1974
Crayon, india ink, and pastel
25 x 19$\frac{11}{16}$
Collection of the artist

South Africa, the Cape of Good Hope, Action
1974
Photo-etching and pastel photo-lithograph
29¾ x 22$\frac{1}{16}$
Museum of Israeli Art, Ramat Gan

Drilling
26 April 1974
Photographs and text
Collection of the artist

Biography/Range of Adaptation
23 June 1974
Photographs and text
Collection of the artist

Language of Art, begins 1973

Choice of Location
1973
Silk-screen on sewn cloth containing a reproduction
$20\frac{7}{8}$ x 13
Museum of Israeli Art, Ramat Gan

On Drawing, a Manifesto
1973–74
Conte crayon and graphite
$25\frac{3}{4}$ x $19\frac{3}{4}$
Collection of the artist

Covered Prints
1974
Silk-screen on canvas with cloth covered frame
$33\frac{7}{8}$ x $30\frac{1}{4}$
Museum of Israeli Art, Ramat Gan

Visual Mathematics, begins 1975

Definitions 1–17
1975
Oil on graph paper
Each $22\frac{1}{8}$ x 25
Collection of the artist

Definitions 1–17: Zero Element
1975
Felt pen, oil, and napkin on photo screenprint
One from a series of seventeen, $27\frac{1}{2}$ x $19\frac{1}{4}$
Tel Aviv Museum of Art
Gift of the artist

Definitions 1–17: Unity Element
1975
Felt pen, oil, and napkin on photo screenprint
One from a series of seventeen, $27\frac{1}{2}$ x $19\frac{1}{4}$
Tel Aviv Museum of Art
Gift of the artist

Definitions 1–17: Identity Element
1975
Felt pen, oil, and napkin on photo screenprint
One from a series of seventeen, $27\frac{1}{2}$ x $19\frac{1}{4}$
Tel Aviv Museum of Art
Gift of the artist

Definitions 1–17: Negative
1975
Felt pen, oil, and napkin on photo screenprint
One from a series of seventeen, $27\frac{1}{2}$ x $19\frac{1}{4}$
Tel Aviv Museum of Art
Gift of the artist

Man with Fire
1976
Oil on tablecloth
44 x $44\frac{1}{2}$
Collection of the artist

Walking Man
1976
Oil on tablecloth
42 x 43
Collection of the artist

Non-Euclidean, begins 1975

Blue State
1980
Charcoal, brush, and ink
Nine from a series of 28, each 27½ x 39⅜
Tel Aviv Museum of Art
Gift of the artist

Confrontations of Painting and Formula
1982
Acrylic, pencil, and collage
Two from a series of five, each 27½ x 39⅜
Tel Aviv Museum of Art

Language Trees, begins 1976

Noun Phrases–I [from Phrase Structure Trees Circuits]
1976
Felt pen, oil, and graphite
One from a series of sixteen, 21⅝ x 26¾
Collection of the artist

The Auxiliary Sample³ Derivations of the Perfect
1976
Felt pen, oil, and graphite
One from a series of sixteen, 21⅝ x 26¾
Collection of the artist

The Day Will Come
1995
Acrylic, felt pen, and paper on canvas
59 x 39½
Collection of the artist

I Went Up This Side and Down That Side
1995
Acrylic, felt pen, and paper on canvas
59 x 39½
Collection of the artist

Somebody Must Have Noticed
1995
Acrylic, felt pen, and paper on canvas
59 x 39½
Collection of the artist

Figure, Form, Formula, begins 1976

Shelf
1976
Oil on wood
20⅞ x 20⅞ x 3¹⁵⁄₁₆
The Israel Museum Collection, Jerusalem
Purchased through the gift of the Florence Louchein
Stol Foundation

Figure, Form, Formula: Jerusalem Post
1977
Cut and torn layers of newsprint and ink
Four from a series of twelve, each 12½ x 16⅝
Collection of the artist

Figures 1–59
1977
Oil wash and cutouts
Twelve from a series of 59, each 19⅝ x 25⅞
Collection of the artist

East West Erosion Figure
1977
Synthetic high-gloss enamel, collage,
and torn newsprint
Two from a series of ten, each 16½ x 24¾
Tel Aviv Museum of Art
Gift of the artist

Composition (Coefficients of Painting, Sculpture, Drawing, and Architecture)
1978
Pencil, oil, acrylic, and wood
One from an unnumbered series, 27½ x 33¼
Tel Aviv Museum of Art

Propositional Painting
1980
Acrylic, canvas, and wood
18½ x 31¼ x 1½
Collection of the artist

Color
1986
Gouache and pencil
19¾ x 27¾
Collection of the artist

Square
1986
Gouache and pencil
19¾ x 27⅝
Collection of the artist

Figure
1990
Acrylic and cardboard
68 x 6½ x 4
Collection of the artist

Painting Proposition C
1994
Acrylic, cardboard, and canvas on graph paper
25¼ x 19
Collection of the artist

Painting Proposition D
1994
Acrylic, cardboard, and canvas on graph paper
25¼ x 19
Collection of the artist

Atomic Art, begins 1982

Art
1982
Gouache and pencil
27⅝ x 19¾
Collection of the artist

Relational Art and Absolute Art
1982
Gouache and ink
27⅝ x 19¾
Collection of the artist

Image Understanding System
1985
Ink
20 x 27¾
Collection of the artist

CDC 915 Parallel Photocell Scanning System
1986
Felt pen and graphite
19¼ x 27
Collection of the artist

Electronic Picture
1987
Graphite
19¾ x 27½
Collection of the artist

Document Carrier Input Unit
1988
Gouache, felt pen, and tero set on paper
19⅛ x 27
Collection of the artist

Pacifique—l'objet
1995
Acrylic, cardboard, and paper on canvas
59 x 39½
Collection of the artist

Alphabetique—l'objet, c'est l'oeil
1995
Acrylic, cardboard, and paper on canvas
59 x 39½
Collection of the artist

Normal Art, begins 1973

Spiritual Targets
1988
Acrylic, cardboard, and wood on canvas
72 x 72 x 3
Collection of the artist

Language of Art
1988
Acrylic, cardboard, and wood on canvas
72 x 72 x 10
Collection of the artist

Prodigal Son A
1989
Acrylic and wood on canvas
58½ x 58½
Collection of the artist

Prodigal Son B
1989
Acrylic and wood on canvas
58½ x 58½
Collection of the artist

Prodigal Son C
1989
Acrylic and wood on canvas
58½ x 58½
Collection of the artist

Wars, 1973–91

Sometimes a Tree, Sometimes a Print II
1973
Silk-screen on cloth and twigs
3 x 21½ x 1
Museum of Israeli Art, Ramat Gan

Still Life with Helicopter (Nature Morte)
1974
India ink, charcoal, and incision
19½ x 25½
The Israel Museum Collection, Jerusalem
Gift of Arturo Schwarz

First Aid Kit of Primary Colors
1974
Bag made of sewed cloth, oil, and stamps on paper
27¼ x 19½
The Israel Museum Collection, Jerusalem
Gift of Arturo Schwarz

First Aid Kit
1980
Etching on canvas bag
8½ x 25¼
Museum of Israeli Art, Ramat Gan

Drawing of the Lebanon War
1982
Pen and brush with ink, adhesive letters,
and collage
Two from a series of 10, each 27½ x 19⅝
Tel Aviv Museum of Art
Gift of the artist

15/1/91
1991
Acrylic, oil, and collage
39½ x 27½
Collection of the artist

10/2/91: In Order to Tell It to the Last Generation
1991
Acrylic, oil, and collage
39½ x 27½
Collection of the artist

10/2/91: RIF
1991
Acrylic, oil, and collage
39½ x 27½
Collection of the artist

11/2/91: Aouto-da-fe
1991
Acrylic, oil, and collage
39½ x 27½
Collection of the artist

Logic Furniture, begins 1995

Subtraction
1995
Acrylic, ink, and canvas on cardboard
30½ x 41½
Collection of the artist

Ratio of a Tab
1995
Acrylic, ink, and canvas on cardboard
30½ x 41½
Collection of the artist

(x) (Vx) Ax for every x
1996
Oil crayon and acrylic
24¼ x 18⅞
Collection of the artist

^, o, ø null set
1996
Oil crayon and acrylic
24¼ x 18⅞
Collection of the artist

A∩B A·B intersection (product) of sets A and B
1996
Oil crayon and acrylic
24¼ x 18⅞
Collection of the artist

V^1 Universe
1996
Oil crayon and acrylic
24¼ x 18⅞
Collection of the artist

aRb is in the relation R to b
1996
Oil crayon and acrylic
24¼ x 18⅞
Collection of the artist

The Remaking of History,
begins mid-1980s

The Foundation of the State of Israel from the
Viewpoint of the Children
Dr. Korczak
1996
Oil, crayon, acrylic, and photographs
27¾ x 19⅝
Collection of the artist

Beating
1996
Oil, crayon, acrylic, and photographs
27¾ x 19⅝
Collection of the artist

Deportation
1996
Oil, crayon, acrylic, and photographs
27¾ x 19⅝
Collection of the artist

Theodor Herzl
1996
Oil, crayon, acrylic, and photographs
27¾ x 19⅝
Collection of the artist

Declaration of the State of Israel by Ben-Gurion
1996
Oil, crayon, acrylic, and photographs
27¾ x 19⅝
Collection of the artist

School
1996
Oil, crayon, acrylic, and photographs
27¾ x 19⅝
Collection of the artist

Artist's Books

Drawings to the Book of Ecclesiastes I–XIV
1969–70
Woodcuts and embossment
8¾ x 24¼
Collection of the artist

1942
Born in Meknes, Morocco

1948
Lives in Marseilles, France

1949
Immigrates to Israel

1970
B.F.A. Fine Arts Department, Bezalel
Academy of Art, Jerusalem

1971
Post graduate studies, Central School of Art,
London.
Instructor, Bezalel Academy of Art, Jerusalem

1973
B.A. Psychology, Sociology, and History of
Art, Hebrew University, Jerusalem

1977
M.F.A. School of the Arts, Columbia
University, New York City

1990
Professor, Bezalel Academy of Art, Jerusalem

1993
Resigns as Professor, Bezalel Academy of Art,
Jerusalem

Selected One-Person Exhibitions

1972
"Drawings," Dugith Gallery, Tel Aviv

"Exhibition of Etchings in the Cowshed of
Kibbutz Nirim,"
Kibbutz Nirim, Negev

1974
"Pinchas Cohen Gan, Activities,"
The Israel Museum, Jerusalem

1975
"Alaska Project Drawings," Rina Gallery,
New York City

1976
"Figurative and Electronic Circuits,"
Max Protetch Gallery, New York City

"Figure, Form, Formula,"
Max Protetch Gallery, Washington D.C.

1977
"The Language of Art and the History of Art,"
Max Protetch Gallery, New York City

1978
"Pinchas Cohen Gan, Works,"
Tel Aviv Museum of Art

1979
"Pinchas Cohen Gan," University Gallery,
The Ohio State University, Columbus, Ohio

"Propositional Painting,"
University of Rhode Island, Kingston,
Rhode Island

1980
"Pinchas Cohen Gan," Max Protetch Gallery,
New York City

1981
"Programmed Figure in Curved Space,"
Noemi Givon Gallery, Tel Aviv

"Works on Paper," Galleriet Gallery,
Lund, Sweden

1982
"Pinchas Cohen Gan,"
San Francisco Art Institute, California

"Black Sabbath 1982," Max Protetch Gallery,
New York City

1983
"Pinchas Cohen Gan, 1983,"
Modern Art Museum, Haifa

1984
"Pinchas Cohen Gan,"
Gallerie Schumacher, Köln, Germany

"Pinchas Cohen Gan, New Works,"
Sara Gilat Gallery, Jerusalem

1985
"Pinchas Cohen Gan, Homeland B,
A Painting Model," Gimel Gallery, Jerusalem

1986
"Paintings 1986," Meimad Gallery, Tel Aviv

"Painting and Anti-Thesis,"
Gimel Gallery, Jerusalem

1987
"Paintings 1987," Dvir Gallery, Tel Aviv

1988
"Pinchas Cohen Gan, Prints, 1968–1988,"
The Museum of Israeli Art, Ramat Gan

1989
"Jew," Meimad Gallery, Tel Aviv

1990
"Paintings Remember," Artists' Studios,
Tel Aviv

1992
"Pinchas Cohen Gan, Works on Paper,
1969–1992," Tel Aviv Museum of Art

1994
"Pinchas Cohen Gan," Givon Art Gallery,
Tel Aviv

1996
"Pinchas Cohen Gan," Givon Art Gallery,
Tel Aviv

Selected Group Exhibitions

1972
"From Landscape to Abstraction:
From Abstraction to Nature,"
The Israel Museum, Jerusalem

1974
"Beyond Drawing," The Israel Museum,
Jerusalem

1975
"The Ninth Biennial for Young Artists,"
Musée d'Art Moderne de la Ville de Paris

"The Fourth International Exhibition of
Drawing,"
Museum of Modern Art, Rijeka, Yugoslavia

1977
"Ten Israeli Artists," Louisiana Museum,
Humlebaec, Denmark

"Documenta 6," Kassel, Germany

"Art on Paper," Weatherspoon Art Gallery,
The University of North Carolina at
Greensboro

1978
"Seven Artists from Israel,"
Los Angeles County Museum of Art,
California

1979
"The Hidden Exhibition," Chelsea Hotel,
New York City

"Tel-Hai 80," Contemporary Art Meeting,
Upper Galilee, Israel

1982
"Artists of Israel, 1920–1980,"
Memorial Art Gallery of the
University of Rochester, New York

1984
"Eighty Years of Sculpture in Israel,"
The Israel Museum, Jerusalem

"Dynamic Visions, Contemporary Art from
Israel," The Chicago Public Library
Cultural Center, Illinois

1985
"De la Bible à nos jours," 3000 Ans d'Art,
Grand Palais, Paris

"Milestones in Israeli Art,"
The Israel Museum, Jerusalem

"Weisman Collection in Tel Aviv Museum of
Art," Tel Aviv Museum of Art

1986
"The Want of Matter: A Quality in Israeli
Art," Tel Aviv Museum of Art

"Art Israel, the 1980s," Spring Space Gallery,
New York City

1987
"The 19th International Biennial," São Paulo

1988
"40 From Israel, Contemporary Sculpture and
Drawing,"
The Brooklyn Museum, New York
Bass Museum, Miami Beach
Museum of Modern Art, Mexico City

1990
"Drawing," The Israel Museum, Jerusalem

1991
"Routes of Wondering," The Israel Museum,
Jerusalem

1992
"The International Biennale, Istanbul," Turkey

1993
"The Second Dimension: Twentieth-Century
Sculptors' Drawing from The Brooklyn
Museum Collection,"
The Brooklyn Museum, New York

"Memories of/for the Future,"
Sagacho Exhibit Space, Tokyo, Japan

1995
"From the Rita and Arturo Schwarz Collection,"
The Israel Museum, Jerusalem

aRb is in the relation R to b
1996
Oil crayon and acrylic
Collection of the artist

Biography of Creation

Pinchas Cohen Gan

1942–69

Semi-Conceptual Experiential Art

Formula

Standard and classical art language

The Genetic Code

Allah

Comparative table of the various alphabets

A Christian cross with five pictures on it. Each picture represents an event from the Hebrew Bible. From a twelfth-century manuscript.

Dr. Whitney

1973

Active in the "Art & Science" group at
the Bezalel Academy of Art, Jerusalem

Formula
Artistic application of analytic geometry

Interpretation
Simulative artistic translation of a map representing
the present population volume of Jerusalem in form
and color, and a future urban architectonic plan of
the city of Jerusalem according to computational
principles of analytic geometry (quantitative
measurement)

Dr. Noll

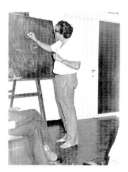

Professor Abraham Molés

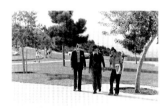

Dr. Bonacic

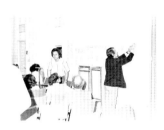

Professor Frenke

Dr. Benthal

Professor Kepes

1970–75

Art activities in the context of culture and nature

Formula

$A = f(N \cdot C)$

Interpretation

Art is a function of coefficients of culture and coefficients of nature

The first two steps in constructing Benoît Mandelbrot's Peano-snowflake curve.

PARIS

Professor Teshima, president of the Makoya religious sect (Japan) with the artist in Jerusalem, 1967

Deportation of Jews, 1941–45

Panel on the Arch of Titus showing the carrying of the Menorah, with a double octagon base, as part of the spoils in the triumphal procession following the subjugation of Judea in 70 C.E. From *Encyclopedia Judaica* 11 (Jerusalem 1972), pp. 1355–56

1976

Concrete formulation in painting, sculpture and architecture of the formula $A_1 = f(N \cdot C)$

Interpretation

A segment of art is a function of culture and nature.

Michelangelo, the Tomb of Julius at the Church of San Pietro in Vincoli, Rome, as it appears today

Jantar Mantar, an eighteenth-century observatory, New Delhi. From the *Reconciliation with Asia* project, 1975.

The Cathedral in Cologne, Germany

1977

Iconographical confrontation of the components of figure, form, formula, in an artwork

Formula

$A = R(F,F,F)$

$A = R \ F \ F \ F$

Interpretation

An artwork is equal to the correlations among figure, form, and formula

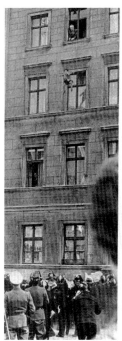

Checkpoint Charlie, Berlin Wall. From *At the Reichstag,* September 1983

Shakespeare

The three basic states of logical circuits

1978

The fourth dimension—geometrical investigations

Formula

The fourth dimension is formed by the direction between two three-dimensional bodies.

Formula: $D_4 = 3D \; S \; 3D$

Intrepretation

The fourth dimension is the space (S) created between one three-dimensional body and another

Articles and religious requisites confiscated by the Nazis, sorted by Jewish curators wearing a yellow star, 1942–45. From the Jewish Museum, Prague

1979

Non-Euclidean geometry is based on
concave and convex surfaces

Formula

The appropriate graphic description is the relation of
a point in space to a corner

$$D_3 = AB \; R \; 3D$$

Interpretation

The third dimension is created from the relation of
an imaginary point A, on a line CB, to a three-
dimensional corner 3D

1980

Meta-formal Art

Interpretation

Construction of an art language based on scientific
laws (investigation begun in 1976, New York)

1981

Art as a Mathematical Reality

Interpretation

An essay on the "ars combinatoria," which deals
with a universal method for creating an art language
inspired by mathematics

A Simple Event, film by Shurab
Shahid Salas: Monotony and
Routine

1982–84

Atomic Art

Interpretation

Construction of an art language based on rules of
syntax, rules of grammar, and rules of visual
representation, inspired by science and its products

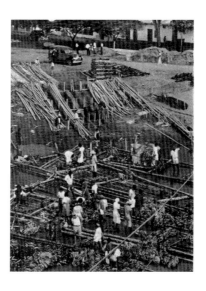

Lateral displacement of road near
Arvin, California, caused by the
Arvin-Tehachapi earthquake of July
25, 1952

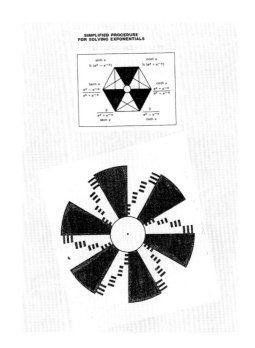

1985–86

Poetica Mathematica

Interpretation

Simulative correlation among art languages, poetry, text, and image

1987

Critical (Total) Art:
Hermeneutic Model

Interpretation

Creation of a systematical model for the
interpretation and translation of the postmodernistic
and deconstructivistic art language

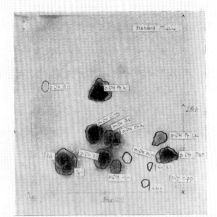

Fig. 16.2. Two-way separation of a mixture of sixteen authentic
phenolic acids, using the solvent pair *IPrAm/BzA* and located
with the nitraniline reagent; 3-OH anthranilic acid is un-named,
and runs to the upper right of *o*-OH hippuric acid. Because of the
variable background colour, the wetness of the paper, etc., these
chromatograms are difficult to photograph.

Key: *o*-OH = ortho-hydroxy; *m*-OH = meta-hydroxy; *p*-OH =
para-hydroxy; Bz = benzoic; Lac = lactic; Man = mandelic;
Ph = phenyl; Hipp = hippuric; Ac = acetic; Caff = caffeic;
Van = vanillic; Fer = ferulic; Cinn = cinnamic; 5HIAA =
5 hydroxy-indolyl-acetic.

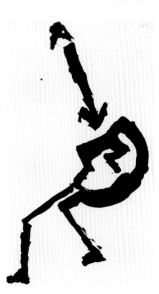

109

1988

Bibliae Principia Descriptiva

Interpretation

Construction of an ethical-logical model for
elucidation of the Hebrew Bible

1989

Bio-Simulation

Interpretation

Construction of a code language for futuristic art
that defines the transition from matter to spirit and
vice versa, via biological being

1990

Syntax of Painting and Sculpture

Formula
The dictionary is a kind of computer program that stores my artworks of the past twenty years in a format of modular semantics.

Interpretation
The relationships among the art coefficients in space are six-dimensional: On the one hand, correlation among image, text, and concept; on the other, confrontation on three levels: dialectical (deductive), taxonomic (classificatory), semantic (syntactic).

November 1922: the British archaeologist Howard Carter and an Arab workman at the archaelogical excavations at the tomb of Tutankhamen carrying a wooden sculpture of the Pharaoh king who reigned 3,000 years ago

1991

Art as a Service

Thesis

The artist is a curator of testimonies dealing with collective memories.

Process

During 1991, I worked on the book *And These Are the Names*, which includes 100 drawings presenting 100 Jewish communities destroyed by the Nazi regime in Europe and North Africa.

1992

Paris Diary

During the year 1992, I stayed in Paris seven months. Dealing with two main subjects:

1. The revival of my mother tongue: French

2. The end of Avant-Garde Art

(Which turned out to be the official art in European museums. See the exhibition catalog *Manifest 1960–1990* [Paris: Centre Pompideu, June 1992])

Process

Creating artworks as comments on those subjects

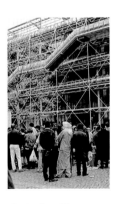

Centre Pompideu opening of "Manifest 1960–1990"

Courbet + Formula

113

1993

Permutation Theory

Thesis

An advanced formula can explain the complexity of art creation.

Interpretation

A systematic art theory can't succeed without an objective representational world. The changes in the art movements and art styles are measureable.

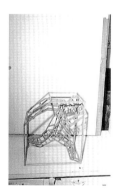

Systematic 3-D figure
in space.

1994

Remaking of History

Thesis

There is a relevant contemporary art situated in the periphery (outside of New York City).

Projection

The above thesis is reviewed and proved in autobiographical perspective.

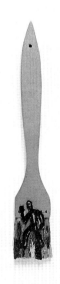

1995

Art Law and the Social Order

Thesis

Should the ethical laws prevalentent in human society conform to the semantic laws established by R. M. Hare, or should they follow the categorical imperative as declared by I. Kant? Contemporary theories of justice base their principles on claims, rights, obligations, duties, and punishments.

Modern society gradually ignores basic human rights. Identifying moral laws with grammatical rules or bold semantics is wrong.

Ramifications

The aim of this thesis is to confront the moral system with the art world.

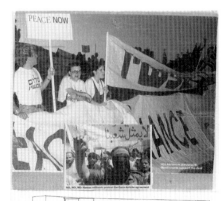

$P \lor Q$ P or Q

Logic Furniture—> + Peace now

1996

The New Avant-Garde Characteristics

1. Computer software creates a product.

2. Artists create (standard) art.

3. Software creates (technological) art.

4. Man compiles softwares.

5. Art serves man.

Conclusion

There is no contradiction between the art of sublime and permutation art theory.

man, figure, formula = man, art, culture

Art kept me alive.

Pinchas Cohen Gan